Hayward Gallery, London
14 November 1985–23 February 1986

Arts Council of Great Britain

Torres-García:

Grid-Pattern-Sign

Paris-Montevideo 1924-1944

The exhibition will travel to:

Barcelona, Fundació Joan Miró
13 March – 4 May 1986

Düsseldorf, Städtische Kunsthalle Düsseldorf
July/August 1986

The Arts Council would like to thank the Torres-García
Foundation for their welcome collaboration on this
catalogue.

Exhibition organized by Susan Ferleger Brades
assisted by Patricia Larder MacAlister

Introductory text edited by Irena Oliver
Designed by Dennis Bailey/Editorial Design
Consultants

Translations by David Macey and
Cecilia Buzio de Torres

Printed and bound in Great Britain by
Westerham Press

Cover: **Constructive painting 3**, 1937 (details).
Collection Royal S. Marks, New York (no.90)

Inside front cover: Torres-García in his first studio
in Montevideo, Calle Isla de Flores 1715, c.1934

Contents

Lenders

Albright-Knox Art Gallery, Buffalo, New York
Museo de Bellas Artes, Caracas
Museo Nacional de Artes Plásticas, Montevideo
The Solomon R. Guggenheim Museum, New York
The Museum of Modern Art, New York

CDS Gallery, New York
Estudio Actual, Caracas
Sidney Janis Gallery, New York

Mr Maurice Biderman
Mr and Mrs D. Brillembourg, Florida, USA
Bernard Chappard, New York
Herbert F. Gower Jr and Royal S. Marks, New York
Mrs Alice M. Kaplan
Mr and Mrs Meredith J. Long
Royal S. Marks, New York
Clara D. Sujo, New York
Cecilia de Torres, New York
Richard S. Zeisler, New York

Torres-García Estate, New York

Private Collections

Foreword

In Latin America Torres-García has long been considered a modern master but his work has been little seen in public exhibitions here. Although born in Uruguay, Torres-García lived most of his adult life in Europe. His first years as an artist were spent in Barcelona, followed by a few years in New York, Italy and Southern France. His art came to maturity during the late 1920s while he was living in Paris. When he returned to his native Montevideo in 1934, his artistic philosophy was already formed.

Torres-García's work had two primary sources: geometric abstract art, influenced by Mondrian and Van Doesburg and prominent in Paris in the late twenties, and pre-Columbian art which, in fact, he first learned about in Paris; his interest in it not unnaturally developed upon his return to Latin America. Torres-García's use of symbols, and rejection of a purely abstract idiom, removed him from the 'Neo-Plasticist' camp; his use of Indo-American imagery, as well as of more immediately recognizable images from daily life, anticipated the pictographic paintings of the Abstract Expressionists, although the opportunity to see his work in this context has been rare. Torres-García's status in European and North American art has thus been rather unsettled. However, his combination of two seemingly disparate sources coupled with his need to unite both modern and ancient traditions, has resulted in an intuitive and inventive pictorial language which deserves a wider public.

The last major exhibition in Europe of Torres-García's work was held in Paris in 1975. When that exhibition travelled to Rio de Janeiro, a museum fire caused the loss of or irreparable damage to many of Torres-García's most important works. Among those that remain, few have to date been seen in public.

This exhibition concentrates on the paintings, drawings and constructions in which Torres-García's 'Universal Constructivism' developed and reached its fullest expression. At the Hayward Gallery, it is shown with *Homage to Barcelona*, in which some of Torres-García's earlier work is included. The exhibition will then travel to the Fundació Joan Miró in Barcelona and to the Städtische Kunsthalle Düsseldorf; it will be shown in Düsseldorf with exhibitions of Siquieros and Lam. We have particularly appreciated the interest which Rosa Maria Malet, Director of the Miró Foundation, and Jürgen Harten, Director of the Kunsthalle, have taken in the project from its inception and the opportunities their showings offer to see Torres-García's work in different contexts.

In the hope that the exhibition might tour in the United States following its European showing, the Arts Council has prepared the exhibition in collaboration with the American Federation of Arts. We have found this first collaboration especially rewarding and would like to extend our thanks to the AFA's Director, Wilder Green, and to Jane S. Tai, Associate Director, and Jeanne Hedstrom, Exhibition Co-ordinator.

The exhibition has been selected by Margit Rowell, Curator at the Musée National d'Art Moderne, Centre Georges Pompidou. Ms Rowell's longstanding interest in Torres-García's work is reflected in the total commitment with which she has approached this project. We have been fortunate to work with her and are grateful for the care and attention she has given to the selection, to the concept and details of the exhibition overall, and to the catalogue, for which she has written the introductory essay.

The exhibition could not have been achieved without the collaboration of the Torres-García family. Our deepest thanks go to Cecilia de Torres for her patience, her goodwill and enthusiasm, and her tireless work on behalf of the exhibition. Torres-García's widow, Manolita, and his children, Augusto, Ifigenia and Olimpia, not only extended their hospitality to Ms Rowell but have readily shared information and insights which have stimulated ways of approaching Torres-García's work afresh. Our thanks go as well to Royal S. Marks and Herbert F. Gower Jr in New York who have lent most generously from their major collection of Torres-García's work and provided documentation helpful for our research.

We would also like to thank Carmen Gimènez and Paloma Acũno at the Ministerio de Cultura in Madrid and Madame Simoni at the Musée de l'Homme in Paris for the assistance they gave to Ms Rowell. In London, we would like to express our gratitude to Michael Raeburn for his help with catalogue documentation and to Paul Williams for his design of the installation at the Hayward Gallery.

The Arts Council would particularly like to thank the Torres-García Foundation for their welcome collaboration on this catalogue.

Finally, but not least, our warm thanks to the owners of Torres-García's works – those listed by name on page 6 and those who wish to remain anonymous – for their support and most welcome involvement in this exhibition.

Joanna Drew *Director of Art*

Susan Ferleger Brades *Exhibition Organizer*

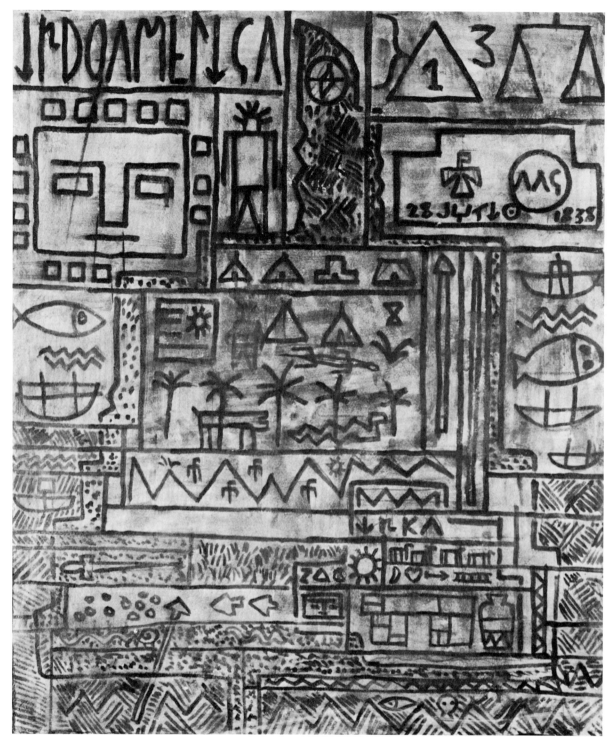

J. Torres-García, *Indoamerica*,
28 July 1938. Oil on canvas,
100 × 80cm. Private Collection,
Buenos Aires, Argentina.

Order and symbol: the European and American sources of Torres-García's constructivism

Margit Rowell

Joaquín Torres-García is one of the few major artists of the early twentieth century whose art has not been reassessed in recent years. Long identified with a certain School of Paris – that of the international community living there which, in the late twenties and early thirties, was briefly involved with geometric abstraction – his art has always appeared as an anomaly within that context. Even though his paintings were constructed according to a geometric grid system based on the Golden Section, and obeyed other abstract laws (flatness, and also non-objective colour and organization), according to his critics – even among his contemporaries – they were too figurative, too humanistic, too emotional. Torres-García did not deny this. Indeed it was one of his objectives for his art, which he defined in terms of a fundamental spirituality of the kind that is found in primitive art. The uneasy marriage of a rational order and a primitive vision engendered an art form that does not fit into any neat category. Yet it is precisely for this reason that Torres-García's oeuvre is unique. In more specific terms, its combined references to European geometric abstraction and to prehistoric or pre-Columbian art constitute the true significance of his 'Universal Constructivism'.

At the outset, it seems important to situate the emergence of Torres-García's Universal Constructivist style in order to understand the artist's critical destiny. In the late 1920s, when Torres-García arrived in Paris and began the transition toward his constructivist style, the artistic stage was dominated by geometric abstraction (including Neo-Plasticism) on the one hand and by Surrealism on the other, two movements which appeared antithetical, but which were inspired by similar responses to the state of the world. Both groups of artists were reacting against what they saw as the rampant materialism and overriding rationalism of society. Whereas the artists of geometric abstraction sought to transcend the phenomenal world and to express its essence through an ideal geometry, the Surrealists sought to liberate the images and processes of the human subconscious. The iconography of the first corresponded to a higher metaphysical order; that of the second to primordial disorder. Since artists of both convictions sought to depict an essence, they rejected the representation of nature or the depiction of objects. Their thinking was on a higher plane, far from the pragmatism of the world around them. Whether idealists, formalists or poets, they aspired to reconstruct the world.

Like Piet Mondrian and Theo van Doesburg, Torres-García was a Platonic idealist and sought to translate an abstract universal order in his paintings. Yet he did not disparage Surrealism, because he saw in it the expression of other fundamental qualities of the human spirit. Equally, he was concerned with the specific reality of the painted surface. He thought colour and brushstroke were as necessary to pictorial expression as the underlying ideas or content. This approach, however, was considered too eclectic, and was almost completely unacceptable to his colleagues. The Neo-Plasticists found Torres-García impure, and the Surrealists found him too much of an idealist. Thus he was relegated to a marginal position, both in his own time and in the subsequent history of Western art. The work of Torres-García, however, is far more complex in its sources and intentions than its tenuous links to these Parisian movements would imply. His contribution to the art of our century must be considered on its own terms.

Life: Barcelona, New York, Paris, Montevideo

Torres-García was born in Montevideo, Uruguay in 1874. His father was a carpenter of Catalan stock, whereas his mother was Uruguayan, with some Indian blood. In 1891, the

Fig. 1. J. Torres-García, *Mujeres de pueblo (Village women)*, 1911. Oil on canvas, 74 × 100cm. Private Collection, Barcelona.

family moved to Spain, settling first in Mataró, the father's family's birthplace, and then in Barcelona in 1892. It was here in the Catalan capital that Torres-García, at eighteen, discovered the art, philosophy and literature of classical European culture. It was a revelation. He studied at the Academia de Belles Arts and at the Cercle Artístic de Sant Lluc. He met other aspiring artists, including Joan and Julio González. He read and studied avidly and became particularly interested in Hellenistic philosophy and art as the expression of a higher ideal. And he developed a neo-classical decorative style, related to *Noucentisme,* a literary and artistic movement which emerged in Catalonia around the turn of the century (fig.1). This somewhat nationalistic movement represented a reaction against various nineteenth century styles: academicism, romanticism, even French Impressionism. The *Noucentiste* painter aimed for classicism and objectivity, achieved through flat pastel colours, clean contours, sculpted volumes and idyllic Mediterranean pastoral or allegorical subjects.

For a while Torres-García's Barcelona career was relatively successful, and by 1904 he was exhibiting publicly. Also in 1904 he worked with Antoni Gaudí on the stained glass windows for the Cathedral at Palma de Mallorca and in 1905 on the windows for the Sagrada Família in Barcelona. Despite his respect for Gaudí's genius, he did not share the Catalan architect's allegiance to nature and organic structure which were foreign to his own concept of order in relation to the classical ideal. It follows that when Torres-García discovered French art in 1907, the year of a major exhibition in Barcelona, he was impressed by the classical spirit and forms (but not the sentimentality) of Puvis de Chavannes.

Torres-García obtained commissions for decorating public buildings as early as 1908. In 1912–13, he was commissioned to do an enormous mural cycle for the Barcelona Palace of the Generalitat. He worked on these murals, which represented his greatest achievement in his classical allegorical style, until a change of government interrupted the commission. The murals were never finished, and the commission was passed to another artist. Disheartened, Torres-García left Barcelona to settle in the country, in nearby Tarrasa. There he taught in a progressive school, made his first wooden toys (as pedagogical tools), wrote his first theoretical texts defending neo-classicism and painted friezes and murals in private villas in the surrounding countryside. Although he continued to visit and exhibit in the Catalan capital, he was disenchanted with the Barcelona cultural scene.

In the Spring of 1920, with the firm conviction that Barcelona was a backwater, Torres-García decided to go with his family to New York, where he hoped for recognition, financial security and a propitious context for the develop-

ment of his art. This too proved a disappointment. Whereas he found evidence of a modern outlook in advertising and graphic design, even in New York the artistic scene was dominated by academic factions. The potential income-earning resources which he had hoped to exploit – as a decorator and toy-maker – also proved practically useless. One of the sole positive aspects of his two-year stay in New York was the moral and financial support of Isabelle Whitney, who not only gave him a monthly stipend (in exchange for paintings) and a place to work (at the Whitney Studio Club on West 4th Street), but introductions and help in showing his work. In April-May 1921, she exhibited work by him at the Studio Club, with Stuart Davis and Stanislaw Szukalski. Finally, in July 1922, she bought enough paintings to pay for a passage back to Europe for Torres-García and his family.

Torres-García experimented with a schematic graphic style during his New York period, as well as during the subsequent four years spent in Italy and Southern France (at Villefranche-sur-Mer). In this style, based initially on his observations of city life, he intended to capture the essential contours, axes and loose spatial relationships of the subjects depicted. Although he had painted street scenes in Barcelona, the dynamic environment and boldly graphic scenery of New York encouraged him to pursue this theme in his new style. So that although his official style remained neo-classical, he began to develop a parallel, more contemporary, or at least more internationally acceptable, idiom in the privacy of his studio. When, in June 1926, while he was still living in Villefranche, Torres-García had his first exhibition in Paris, he sent works of both painting styles. His *noucentiste* or 'fresco' manner was harshly criticized, but his schematic and graphic style aroused some interest and attention. So in September 1926, the artist decided to move his family to Paris.

The impact of Paris on Torres-García's development was immense. It was in Paris, where he remained until 1932, that he discovered what it meant to be an artist.[1] He looked back on his colleagues in Barcelona as bourgeois decorators and illustrators. He abandoned his neo-classical style definitively and began searching for a more modern and meaningful artistic language. It took him only two years to develop both the ideas and the imagery of what he would come to call 'Universal Constructivism', the underlying philosophy of which was absolutely consistent with his earlier thinking. Its essence can be found, for example, in his *Notes sobre art*, published in Gerona in 1913. Based on a neo-Platonic vision, art for Torres-García was an ideal representation of reality, not its perceived appearance. Whereas in the early years this was depicted by ideal figures and landscapes in a neo-classical idiom, the paintings after 1929 are characterized by a measured gridded structure representative of an invisible metaphysical order, and schematic images or signs, evocative of the abstract *idea* of objects, the two combined to constitute a total world view.

Once settled in Paris, two factors turned out to be crucial to Torres-García's development. The first was his encounter with a group of artists devoted to geometric abstraction; the second was his discovery of primitive art. Torres-García's friendship with Michel Seuphor and their joint founding in 1930 of *Cercle et Carré* – ostensibly to combat Surrealism – is fairly well documented.[2] His relationship with Theo van Doesburg was more complex. The two artists met in 1928, a year before Torres-García met Mondrian; he probably met Georges Vantongerloo at around the same time. Although he developed friendships with all three, he was closer to Van Doesburg, possibly due to the latter's more outgoing personality but also because he was in sympathy with Van Doesburg's more humanistic vision. He may have found Vantongerloo's approach too rigorously mathematical, and Mondrian's too ascetic, even though his admiration for the latter knew no bounds.[3]

At the time that Torres-García met Van Doesburg, the latter, although he was the younger by nine years, had been working in a more sophisticated intellectual climate for over a decade, and he had a solid body of work behind him, having formulated his own theoretical position as early as 1916. His culture-versus-nature attitude had evolved from a Dada standpoint; he rejected nature as a model and any sort of mimetic representation; on the contrary, he thought art should translate a universal harmony through formally balanced volumes, materials, lines, shapes, colours and light, and it should be free from all extra-artistic references – literary, religious, naturalistic – and also free from individual expression. Van Doesburg did recognize the importance of intuition and emotion, but on the condition that they be controlled by reason. It was this balance between intellect and emotion that defined the creative act and was a true expression of the human spirit.

Torres-García was also intrigued by Van Doesburg's working method. Van Doesburg's earliest abstract work showed a system of distilling images down to their most fundamental lines, axes and planes. To the uninitiated his paintings of 1918–20 look purely abstract but he often started with a natural subject and then attempted to disengage from it its rhythms and balance (fig.2). Angelica Rudenstine has aptly described this process towards abstraction in relation to a specific painting of 1918: '. . . Van Doesburg started from an extremely realistic gouache landscape of considerable size; over this work he placed tracing paper, and with a series of thick black brushstrokes he picked out only the straight lines of the composition (whether vertical, horizontal, or diagonal). Some curves remained in the initial traced efforts to "abstract" the linear quality of the landscape, but these

Fig. 2. Theo van Doesburg, *Composition*, 1920. Oil on canvas, 130 × 80cm. Musée National d'Art Moderne, Centre Georges Pompidou, Paris.

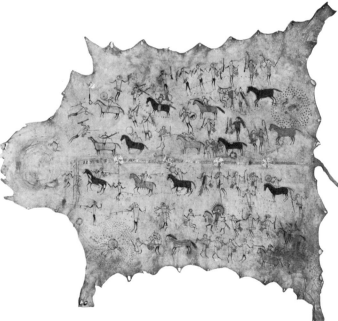

Fig. 3. Painted buffalo hide. Plains Indian, North America. Probably c.1830. Musée du Trocadéro/ Musée de l'Homme (and earlier collections) since 1886.

were suppressed in subsequent drawings. The composition was ultimately executed as a work in stained glass, and its final form was that of a rectilinear grid.'[4]

Torres-García's first constructivist paintings of 1929 (no.20) show the influence of Van Doesburg first in the reduction of objects and figures to their essential contours, axes and relationships, secondly in the elaboration of a grid structure founded on the Golden Section, upon which Van Doesburg also based some of his works. Torres-García's first 'Constructivist' text in 1930[5] also relates closely to Van Doesburg's own texts in its emphasis on order, harmony, proportion; pure painterly non-objectivity as opposed to representation or personal expression; and a balance between the intellect and emotion.

Van Doesburg's presence and example were fundamental to Torres-García's rapid progression towards his own form of constructivism. The Golden Section, which he used consistently starting in 1929, not only provided a structure but a metaphysical justification for his new painting style.[6] However, if Van Doesburg's approach was so immediately significant, it was perhaps because Torres-García was already searching for a more abstract style and also was aware of the Golden Section in a broader historical context. Van Doesburg's example revealed how it could be applied within a contemporary form of expression.

According to Torres-García's eldest son Augusto, it may have been the Spanish painter Luis Fernández who first introduced Torres-García to the Golden Section.[7] Fernández settled in Paris in 1924. According to Augusto, he was a Freemason and versed in many kinds of esoteric knowledge, including the Golden Section, the magic of numbers, medieval symbology, etc. Augusto recalls that Fernández used to take his father to medieval churches in Paris, and not only decipher the iconography of the sculpted motifs but also reveal the hidden arithmetical laws which governed their placements and relationships. Fernández was particularly interested in pictorial semantics and technique. His paintings too, from 1928, were organized according to the Golden Section and even during his later Surrealist period his works were ordered by mathematical progressions, not only in their over-all structure, but in their palette and tonal relationships. Yet even though he constructed his paintings systematically on this basis, he, like Van Doesburg, emphasized the values of intuition and emotion.

Torres-García, as well as being committed to a balance of intellect and emotion, was absolutely committed to the world of nature as the image and representation of all creation and the microcosm of universal order. The metaphysical or mathematical order of geometric abstraction was not enough to translate his world view. And this is where his thinking diverged sharply from that of his immediate circle. When, in 1929, he proposed the formation of a group to

combat Surrealism, his personal objectives were already clear. His concept of Universal Constructivism encompassed rational structure, emotion or intuition and symbolic references to the world of nature. What he sought was a broad humanism in a contemporary expressive form, but this was unacceptable, even to his closest friends. In 1929, Jean Hélion, who was then exploring geometric abstraction, wrote to him:

> The last time we met . . . you spoke to me about your idea of founding a dual group placed under the sign of constructivism. . . . I told you that I thought more reflection was needed as it seemed to me that as then conceived, the group included mutually-exclusive tendencies: on the one side the absolute conviction that nature must not "formally" participate in the structure of the work of art (Van Doesburg, Mondrian, Pevsner, etc., and myself); and on the other painters such as yourself who are convinced that pure constructive art is incomplete. . . . You objected saying that we should form a broadly based group. . . . I admire your art and I have had the occasion to prove it but I do not believe that your will to integrate natural appearances into your work is a way toward truth. . . .[8]

A later text expressed Hélion's views more succinctly:

> Geometry is one thing, humanity is another; their mixture is at once anti-mathematic and anti-human.[9]

Shortly afterwards, presumably referring to the same issue, Van Doesburg wrote to Torres-García in terms that were cordial but uncompromising:

> I do not see the necessity for a group without a principle or ideological foundation. Such mixed groups exist already (the *Surindépendants*, etc.) and only lead to further confusion concerning the new art. I have already explained to you why it seems absolutely necessary to me to constitute a tightly formed group around a new aesthetic idea. I am quite aware that such a group which is in opposition to all others and to public opinion will never be formed either by myself or by anyone else; it will be formed of itself, by a cultural force, now or later, when the time is ripe. For this reason, I will not force myself to form such a group. I will be satisfied if only a few artists agree on the principle of the future art, i.e., an art scientifically constructed, *concrete* art.[10]

In early 1930, Torres-García founded a separate group with Michel Seuphor, without Van Doesburg. The short-lived *Cercle et Carré*, as it was called, embraced a diversity of tendencies, its broad base constituting its inner flaw. Lacking real definition or commitment to a single goal, it could embrace artists as diverse as Mondrian, Vantongerloo, Jean Gorin, Kurt Schwitters, Wassily Kandinsky, Antoine Pevsner, Florence Henri, Marcelle Cahn, Jean Arp, and others who, although delighted to find a vehicle for a stand against Surrealism, shared little in the way of aesthetic convictions. The group held one exhibition in April 1930, brought out three issues of a publication by the same name, and disbanded by the end of the year to be replaced by *Art Concret*, a smaller group under Van Doesburg's direction. Although this group was considered more homogeneous in its aesthetic goals, the paintings by Hélion, Carlsund, Tutundjian, Schwab and Wantz seem to show very little in the way of a common denominator today.[11]

Torres-García's introduction to medieval symbolism and his discovery of primitive cultures took place at approximately the same time. His interest in medieval art stemmed from a long-held idea that up to and through the Middle Ages art had been a spiritual activity, and had a mysterious and magical meaning which was lost with the scientific enlightenment of the Renaissance. His interest in primitive art probably dates from his arrival in Paris, where there was tremendous interest in primitive cultures during the 1920s. Paradoxically, these two art forms, geographically and historically so distant, may have triggered similar responses in his mind. The abstracted emblematic forms of each derived from the world of nature; and these same forms corresponded to a strictly coded order which was familiar and legible to a given spiritual community. Because of this, and also for reasons of formal appeal, these bold painted or sculpted motifs had a strong physical and emotional impact.

While Fernández initiated Torres-García to aspects of medieval symbolism, Augusto initiated him to primitive cultures. Immediately after the family's arrival in Paris, Augusto, who was then fourteen, began going to the flea market with Hélion, and bringing back examples of Oceanic, African and sometimes North and South American Indian art. Augusto soon became a passionate student and collector of primitive art, spending the best part of his time at the Musée du Trocadéro (today's Musée de l'Homme).

Torres-García's early Parisian paintings are influenced by African art in their subject-matter and in their treatment of motifs. The influence of African art was however short-lived. An interest in pre-Columbian art may be documented at least by 1928, the year of a major exhibition of 'Ancient Art from the Americas' at the Musée des Arts Décoratifs in Paris.[12] He is known to have visited this exhibition and the catalogue is still in his widow's library in Montevideo. In 1929–30, through Torres-García's friendship with the Director of the Musée du Trocadéo, Paul Rivet, Augusto worked for a year at the museum, making renderings of Nazca pottery for the inventory files. His father visited the museum often during that period, and Augusto remembers that he was impressed by the pottery, Peruvian textiles and the

painted animal hides then on permanent exhibition (fig.3).

This reference to Torres-García's introduction to native North and South American Indian art is important for two reasons. It serves to dispel the erroneous notion that he was inspired by this art through atavism. It also helps explain why pre-Columbian and Indian motifs appear in his paintings as early as 1931 (he did not return to Uruguay until 1934).

Torres-García knew some recognition and success during the period 1930–31 in Paris. Unfortunately the effects of the New York Stock Market crash reached Europe in 1931–2, virtually collapsing the art market. Once again, Torres-García found himself in financial straits, and decided to move his family to Madrid. Although the following eighteen months were professionally frustrating and financially inconclusive, they were crucial to his later development. His interest in primitive cultures led him to spend long hours in the archeological museum there which at that time housed the 'American' collections as well.[13] Here he found not only further examples of pre-Columbian art but also prehistoric artefacts of the most diverse kinds. All of these objects reinforced his interest in the schematic expression and magical powers of primitive peoples. They inspired an important body of work during the years 1933–4. But, what was even more important, they clarified his theoretical thinking.

Up to this period, Torres-García had attempted to link reason, emotion and nature in a single mode of expression, but he had not arrived at a satisfactory synthesis. Although his objective was criticized as contradictory, he believed in it with conviction even though its rationale or justification was not clear in his mind. His exposure to a more scientific view of prehistoric art – the ethnographic or anthropological view – provided him with the theoretical premises for what he was trying to achieve; indeed it brought support to his general philosophical view.

Prehistoric art, according to ethnographic conventions, may be divided into three cultural and formal phases: the palaeolithic, the neolithic and the Bronze Age. Briefly, these three phases correspond to: a naturalistic representation of animals, people and events; an animist, symbolic interpretation of the same; and, finally, a translation into abstract geometric forms. Torres-García was more sensitive to the neolithic and the Bronze Age cultures than to that of the palaeolithic period. He appreciated the neolithic artefacts for their formal distortions and symbolism which expressed an animist view of the world. He was impressed by the Bronze Age objects because of their crudely drawn geometrical patterns which contained an authentic natural and spiritual vitality. His exposure to these cultures and his introduction to the scientific explanation of their chronological development led him to a more structured and coherent general theory of art, according to which all artistic

enterprises, from the most general (a general cultural movement) to the most individual (a single artist's oeuvre) must pass through three similar stages of form-making and significance. Moreover, the final geometric state must contain the two others: a naturalistic base and a metaphysical or spiritual sense. In broader terms, the final phase represents the birth of reason, once again a stage of consciousness which encompasses physical and emotional experience. It was for these reasons – which he had perceived instinctively – that the geometric abstraction he had seen and known in Paris was unsatisfying to him and incomplete.

This then was the knowledge and experience with which Torres-García returned to Montevideo in April 1934; he had been exposed in Paris to the most avant-garde art in Europe and he had also acquired a broad knowledge of primitive art. In Uruguay, in 1934, there was no interest in Indian cultures of any kind. Although there had been originally a very small indigenous population,[14] by the mid-nineteenth century it no longer existed. Since the native Indians had been essentially agrarian, there remained little in the way of artefacts, and nothing in the way of architecture. Torres-García was interested in the retrieval of prehistoric and Indian cultures in order to give an authenticity both to his own art and to the new art he would ultimately seek to generate, but the impetus for this he had found in Europe, not in his native land.

Montevideo, in 1934, was a city of approximately 130,000 people. Almost all its cultural components were imported. There was little native artistic expression, and even that was contaminated by imported styles, especially a polished ninteenth-century academicism favoured by the bourgeoisie. Any interest in art was based on fashion rather than on knowledge, discrimination or conviction. In fact, Torres-García found that not only the general population but even the population of artists had little awareness of any cultural traditions. This realization encouraged his career as a theorist, historian and teacher, which he came to think of as a vocation or a mission. At first he wrote, lectured and taught, abandoning his painting almost entirely. He wrote his autobiography, founded the *Asociación de Arte Constructivo (AAC)* in 1935, and wrote his first book of theory, *Estructura*. In 1936, he began publication of *Círculo y Cuadrado*[15] in order to disseminate his theoretical ideas. In 1944, he formed the *Taller Torres-García (TTG)* as a working studio for teaching and collective work. The idea was to develop collectively a distinctive style based upon his philosophy of abstraction and upon indigenous Indian traditions. The artists working in the *TTG* did not sign their paintings and sculptures individually; their desire was to forge a collective style. They also worked together on architectural commissions, of which the most important was the mural cycle

for the Hospital of Saint Bois in 1944.[16] In 1945, the *TTG* began publication of *Removedor*.[17]

Like many artists of his generation, Torres-García aspired to a public art, an art which would express a collective consciousness and be accessible to a broad general audience. In the 1940s he received commissions for monumental mural works for public spaces, which were executed by his artist-students in the *Taller Torres-García* – collectively and anonymously. He wanted them to have the same impact and significance in relation to their specific period and culture as prehistoric cave paintings or Romanesque frescoes did to theirs: that of universally meaningful images executed by anonymous hands. The architecture of each project dictated the choice, structure and colour of the images. According to Torres-García's reasoning, since architecture is an abstract art, based on geometry, rhythm and proportion, bound to a function and in no way referential to the natural world, the organization of a building's decorations should be predominantly abstract and contain the same rhythms and proportions as the architectural space itself. This did not mean that real images should be absent, but on the contrary, that a vocabulary of archetypal images would be coloured and ordered according to simple basic laws. In some ways these mural decorations represented the culmination of Torres-García's ambitions.

The works

During Torres-García's transition from neo-classicism to Universal Constructivism (1926-9), he painted portraits and still lifes, and scenes in what became identified as his African or 'negro' style (fig. 4). These paintings show African figures in tropical landscapes; they seem incongruous and difficult to explain in relation to both his earlier and later work. The colours are dark and earthy, the brushwork energetic and impastoed, the figures articulated in an awkward, disjunctive manner. Obviously Torres-García was trying to capture the stylized volumes and primitive energy he saw in African art. These works are the first indications of his discovery of so-called primitive cultures.

At the same time, Torres-García began a real search for abstract forms, particularly in drawings and wooden constructions, true to his conviction that only abstraction could express the ideal he sought in painting. He first used a grid structure at this time, but the grid is neither rigorous nor systematic (nos. 3–6). On the contrary, the gridded forms and geometric configurations of this period appear intuitive and expressive and evoke in some instances the Inca stonework of Peru (fig. 5). Inca masonry was founded on certain astrological and numerical laws as well as upon a need to withstand earthquakes. It reflected a symbolic order and practical concerns. In a sense its geometry was a natural geometry, and this appealed to Torres-García.

Fig. 4. J. Torres-García, *Négresse et éléphant*, 1928. Oil on canvas, 100 × 80cm. Private Collection, New York.

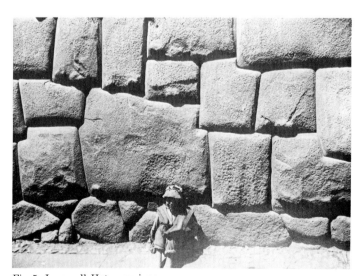

Fig. 5. Inca wall. Hatunrumiyoc, province of Cuzco, Peru. Photograph in collection Musée du Trocadéro/ Musée de l'Homme since early 1930s.

15

Torres-García does not appear to have been satisfied with these drawings and constructions. In 1929, under the influence of his Parisian entourage, he began to rethink his work in terms of the Golden Section (nos.11–13). Throughout the ensuing years his process was to trace a horizontal/vertical grid on the surface of the canvas, the dimensions dictated by the size of the stretcher. The format of the canvas represented the initial module from which all other modules derived in progressive (and decreasing) order. The resulting intersecting structure expressed a universal cosmic order (such as Van Doesburg and Mondrian had found before him) and the order of human reason. Next he would distribute on the picture surface schematic figures or objects, which stood as symbols for specific humanistic notions (hope, love, justice, for example). Finally he determined his palette, creating a pattern of coloured planes in the early works, but later adopting a single colour that unified the surface.

The earliest paintings constructed according to this system (nos.19, 22) show fairly conventional landscape or still life spatial concepts in the relations between figures and objects. By the end of 1929, the ground was a single tone, and the figures were placed in relation to the gridded structure and the total surface, not in relation to each other, or to predetermined spatial conventions. They were thus detached from representative or narrative concerns and existed as autonomous symbols on a unified field.

The wooden constructions of 1929–30 (nos. 23–8) show a more rigorous application of the rules of the Golden Section. They are generally restricted to the primary colours and the tonal gradations of black, white and grey, suggesting ties to the paintings of De Stijl. These are Torres-García's most European and most purely non-objective works. However, this series of investigations was short-lived, quickly supplanted by works in primitive colours (earth reds in particular) and with more primitive forms, although still governed by the Golden Section in their proportions (nos.36–7). They reflect his emerging interest in pre-Columbian art.

By 1930–31, Torres-García's repertory of symbols was fairly well defined (no.31) and included precise references to the cosmos (the sun), the ideal pentameter (the number five), human emotions (the heart and the anchor, representing hope), nature (the fish) as well as references to North American Indian art (the teepee framed by a crescent moon and the sun, such as is found on painted hides). The paintings of 1931 also contain familiar references to a modern context (boats, clocks, motors, skyscrapers) and generalized symbols of the world of nature (leaves, snails, fish). And they are clearly organized; there is an ordered stacking of objects and juxtaposition of ideas. The image or symbol inserted in a given compartment of the grid was dictated by the size and shape of the compartment, and not by an attempt to establish relationships between the symbols in the conventional

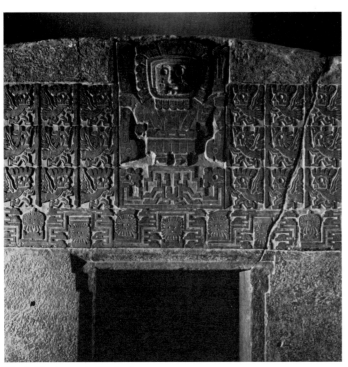

Fig. 6. Plaster cast of *Gate of the Sun,* (detail). Tihuanaco, Bolivia. Exhibited at Musée du Trocadéro/Musée de l'Homme since 1878.

sense. The objective was to express a total world view. Some paintings of 1931 (nos.33–4) show a grid organized as a box-like structure, shaded so as to produce an illusion of depth. The symbols are also shaded, suggesting relief or volume. Torres-García's intention was not to be naturalistic, but to intensify the objects' evocative presence.

Other paintings of late 1931 to early 1932 have a flat decorative patterning, a palette of earth reds, yellows and browns, explicitly primitive silhouettes and a symmetrical and hieratic organization. They demonstrate Torres-García's interest in pre-Columbian art and in particular in Nazca pottery from Peru. For example, *Construction with strange figures* of 1931 (no.38) seems to have been partly inspired by the plaster replica of the Tihuanacan *Gate of the Sun*, then installed at the Musée du Trocadéro (fig.6). The upper part of this monumental door or gate shows a large frontal image of the Sun God Viracocha, flanked on either side by small motifs in a regular gridded pattern. The markings of the central figure, and in particular the white areas of the head and shoulders, are clearly inspired by certain Nazca pottery conventions (fig.7). The profile image on the right in *Construction with serpentine forms* (no.39) also seems to be directly inspired by Nazca motifs (fig.8).

The paintings from 1932, although strictly ordered (expressing the intellect), show an attention to emotion or intuition in their painterliness and shading, and to the world of nature, through their symbols from the animal, vegetal and mineral world. A painting such as *Universal composition: Elements of nature* (no.54) contains an explicit hierarchical structure: the upper part of the drawing expresses reason and intellect (compass, ruler and other measuring devices of time and space); the middle frames express emotion (Christian belief, hope, violence, justice); the lower areas the natural world (vegetal, animal, mineral). In *Composition with primitive forms* (no.55), the 'primitivism' of the motifs – mask-like configurations, leaf and fish fossils (in the central area), an Indian manioc grating implement (in the lower right corner) – is reinforced by the thick lines and pale scumbled surface which recall prehistoric graven images and an ancient stone surface.

During the year that Torres-García spent in Madrid, so crucial to the clarification of his theory and imagery, he discovered artefacts at the Archeological Museum – including a broad range of objects from the palaeolothic period to the Bronze Age, other pre-Columbian artefacts, even Egyptian art – which wrought further transformations on his painting style. In some of the more traditionally articulated paintings of 1933 (nos.58–60), there is a visible loosening of the grid structure which now encloses several motifs in a single frame. The closest parallel for this stacked arrangement of ideograms is in Egyptian hieroglyphics ordered within a frieze or seal. Torres-García's monochromatic

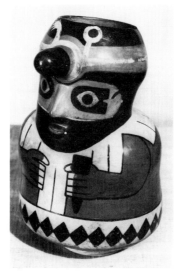 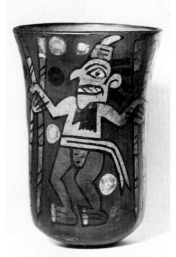

Fig. 7. Anthropomorphic vase, probably representing a warrior. Nazca culture, Peru. Entered Musée du Trocadéro/Musée de l'Homme collection, 1933.

Fig. 8. Polychrome vase. Nazca culture, Peru. Entered Musée du Trocadéro/Musée de l'Homme collection, 1911.

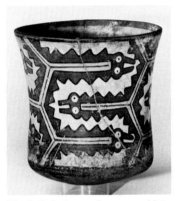

Fig. 9. Polychrome funerary goblet. Nazca culture, Peru. Entered Musée du Trocadéro/Musée de l'Homme collection, 1930.

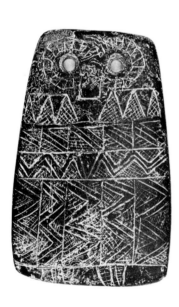

Fig. 10. Female idol. Slate. Bronze Age culture, Vega del Peso, Spain. Museo Arqueológico Nacional, Madrid.

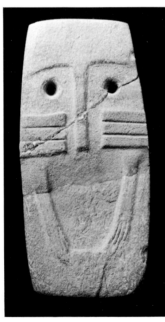

Fig. 11. Female idol. Stone. Bronze Age culture, Garrovilas de Alconetar, Spain. Museo Arqueológico Nacional, Madrid.

vision which emerges at this time may also have been inspired by the chalky surface of Egyptian stone reliefs.[18] Yet his symbols were not Egyptian. The llamas, thunderbirds, snakes, fists and water signs shown an explicitly American inspiration.

Some paintings of late 1933, although they appear quite different in their formal conception, are still constructed on an underlying grid structure (nos.71–2). Here, in a sense, the large flatly coloured anthropomorphic silhouettes constitute both grid and image. In other works (nos.73–4), grid and symbol are integrated in a meandering line, and defined by the flat colour, the positive and negative spaces and the image. Although the strong contrasts and decorative patterning appear to derive from Nazca pottery once again (fig.9), the overall concept and articulation are related to quite different sources. Some (nos.71–2) are certainly inspired by the Bronze Age female idols from Extramadura (in Spain), carved from flat sheets of slate and incised with geometric decorative patterns (fig.10). These same idols continued to influence Torres-García when he returned to Montevideo; a good example is the extremely graphic and stylized *Three primitive constructive figures* (no.99) where the human figures with long frontal arms derive directly from the same Bronze Age culture (fig.11). It was the art of the Bronze Age which for Torres-García represented the ultimate form of abstraction: an art which was predominantly geometric but which retained references to the natural world and also contained spiritual and emotional, even magical, powers.

Upon Torres-García's return to Montevideo and during the next two years (1934–6), he did little painting. His arrival in a cultural context where most artistic styles were imported and where the concept of abstraction was virtually non-existent made him conscious of the need for a style which would be specific to the 'new' world, expressing its mentality and its history. The indigenous Indian arts, which had interested him earlier for their universal symbolism and spiritual and formal values, now corresponded to an urgent necessity.

Uruguay had few authentic national monuments and no Indian archeology. One of Torres-García's first objectives was to build a 'cosmic monument' in stone, which would be a public expression of all his ideas (fig.12). His drawings and paintings of 1935–8 (nos.77–89) are related to this project; they refer once again to the articulation of Inca masonry, representative of an indigenous South American culture and also of a cosmic order.

Many paintings from this period are in black and white. By this time, Torres-García felt that his Universal Constructivism should be defined as order and symbol, with no need for colour. In some of the monochrome paintings with images, for example no.96, the large figures seem to float

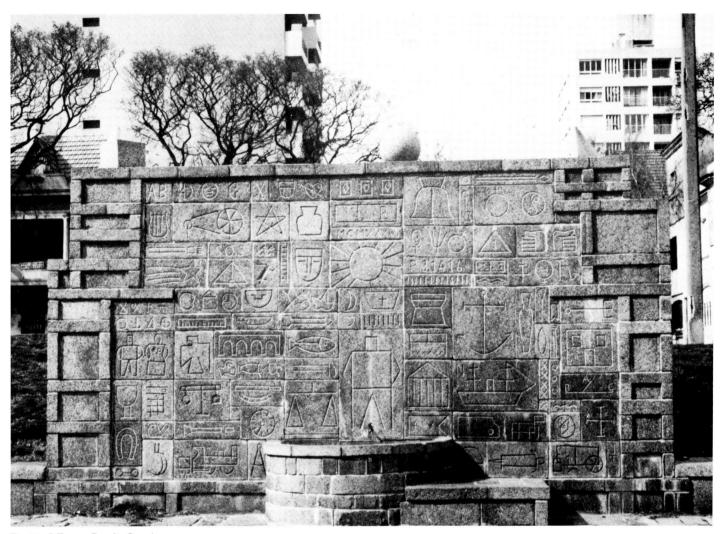

Fig. 12. J. Torres-García, *Cosmic monument*, 1938. Granite. Parque Rodó, Montevideo.

freely, yet this is an illusion. All of them are drawn, measured, and interrelated according to an invisible Golden Section grid. Their distorted silhouettes have a magical presence and express an animist notion of reality. Again their sources may be traced to prehistoric and Indian cultures. The more colourful paintings of this period – particularly those with large human images (nos.100–02) – seem to refer to the flat geometric humanoid forms seen in Peruvian textiles, but the reference is not direct; the images are of Torres-García's own invention.

With a few exceptions, the constructivist paintings from 1938–43 are the most graphic, densely patterned, abstractly constructed and filled with specifically Indian motifs of Torres-García's career. In a sense he had completed the cycle such as he had defined it in his book *Estructura*: from naturalism, to animist symbolism, to abstraction. These paintings, particularly those of 1938–9, fuse structure and symbol in a single unified pattern. In fabric and facture they express the ultimate synthesis of Torres-García's tri-dimensional vision: order/intellect, natural/phenomenal world, and emotion/intuition.[19]

Torres-García was a child of the New World, which is to say that he took something from his father's culture (Europe) and much from his own (the Americas). He reconciled certain modern formal and conceptual conventions with a prehistorical vision and energy, to forge a universal style which appeals equally to reason, to the senses and to the spirit. The Universal Constructivist paintings, drawings and constructions presented here, and spanning the period 1924 to 1943, represent the image and essence of Torres-García's most personal discoveries and ideals.

Notes

1. Interview with the artist's son, Augusto, Montevideo, April 1985. All information in this essay attributed to Augusto is from this interview.
2. See Marie-Aline Prat, *Peinture et avant-garde au seuil des années 30*, Lausanne, 1984; and Gladys C. Fabre, *Abstraction – Création 1931–36* (exhibition catalogue), Münster and Paris, 1978, pp.8–9.
3. Torres-García dedicated his first mature theoretical work, *Estructura*, written in 1935, to Mondrian.
4. Angelica Zander Rudenstine, *Peggy Guggenheim Collection, Venice*, New York, Harry N. Abrams Inc., 1985, pp.222–3.
5. Torres-García, 'Vouloir construire', *Cercle et Carré*, no.1, Paris, 15 March 1930, n.p. [pp.3–4].
6. Golden Section: the name given to an irrational proportion, known at least since Euclid, which has often been thought to possess some aesthetic virtue in itself, some hidden harmonic proportion in tune with the universe. It is defined strictly as a line which is divided in such a way that the smaller part is to the larger as the larger is to the whole (AB cut at C, so that CB:AC = AC:AB). (Peter and Linda Murray, *A Dictionary of Art and Artists*, Harmondsworth, Middlesex, Penguin Books Ltd., 1969.)
7. Torres-García probably met Fernández through their mutual friend Julio González.
8. Letter from Hélion to Torres-García, 18 December 1929. Torres-García archive, Montevideo.
9. In 'Les Problèmes de l'art concret – art et mathématiques', *Art Concret*, no.1, Paris, 1930.
10. Letter from Van Doesburg to Torres-García, 26 December 1929. Torres-García archive, Montevideo.
11. See Prat and Fabre, op. cit.
12. *Les Arts anciens de l'Amérique*, Paris, Musée des Arts Décoratifs, May–June 1928.
13. Today's Museo Arqueológico Nacional; the American artefacts have since been transferred to the Museo de America, Madrid.
14. The Charrúas Indians.
15. Obviously inspired by the Parisian *Cercle et Carré*. There were ten issues (until December 1943).
16. These mural paintings were destroyed along with a large body of Torres-García's work in the fire at the Museu de Arte Moderna, Rio de Janeiro, in 1978.
17. Another periodical in broadsheet format, for the expression of the group's theoretical ideas. It continued publication until August 1953.
18. Of which there are several in the Museo Arqueológico Nacional in Madrid.
19. After 1942–3, Torres-García's priorities changed once again. He favoured primary colours and large flat planes, and occasionally depicted landscape and still life subjects. The late paintings show preoccupations related to his teaching and his architectural commissions. Although they are consistent with his earlier styles, their premises are outside the parameters of this study.

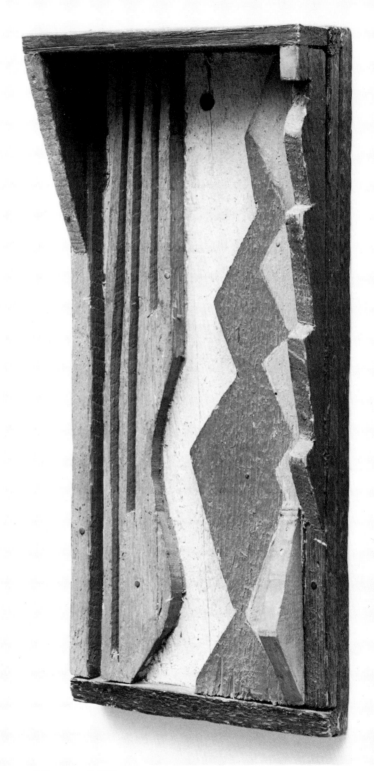

1 **Forms on white ground.** 1924

3 **Structure.** 1927

2 **Abstract form.** 1926

4 **Tubular (pipe) construction.** 1928

5 **Drawing for a monument.** 1928

6 **Abstraction.** 1929

7 **Two abstract figures.** 1929

8 **Abstract form.** 1929

23

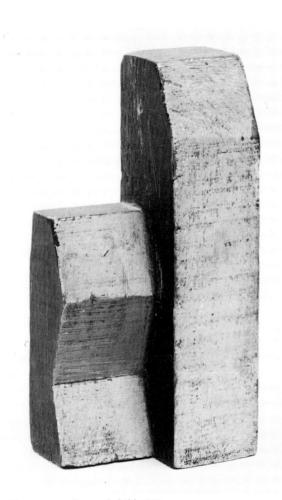

11 **Abstract mother and child.** 1929

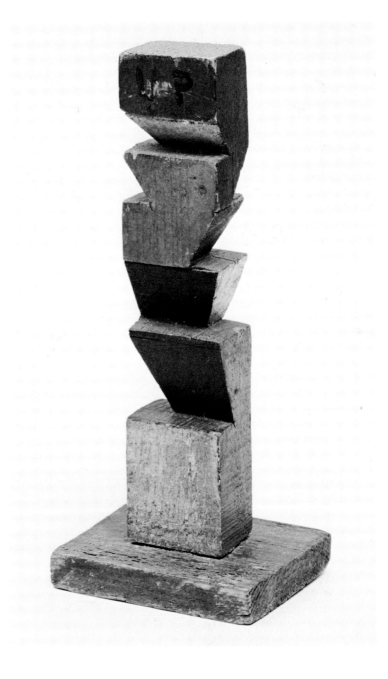

10 **Untitled.** 1929

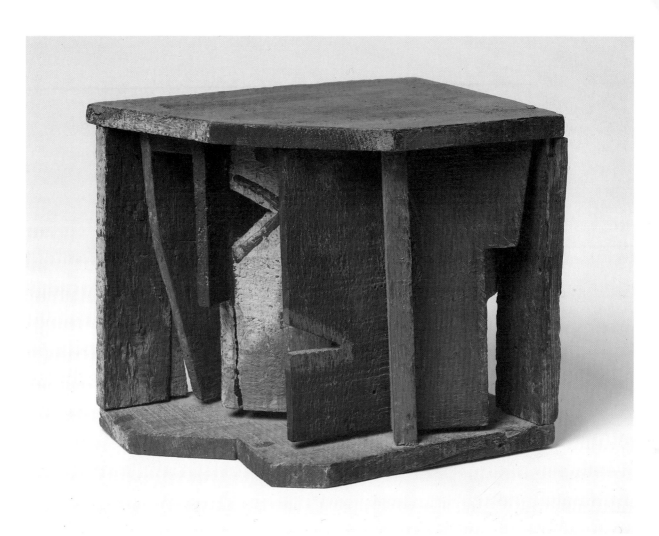

9 **Vertical and superimposed rhythms.** 1927

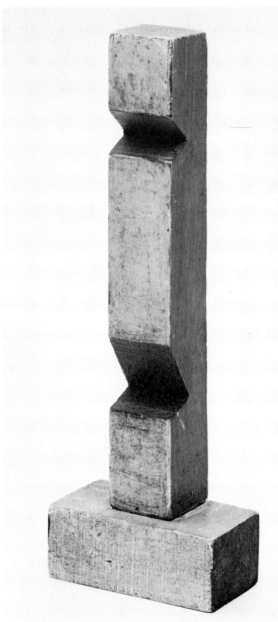

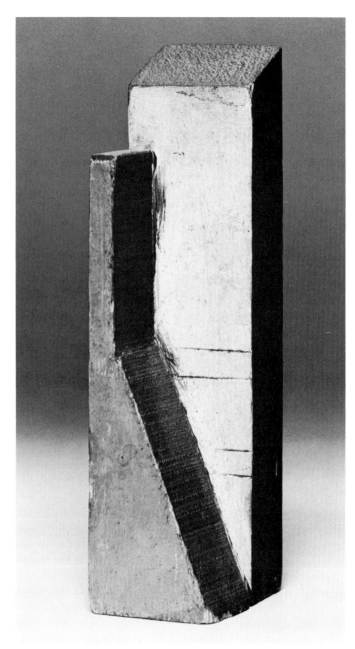

12 **Abstract form.** 1929

13 **Counterpoint.** 1929

14 **Construction.** 1928

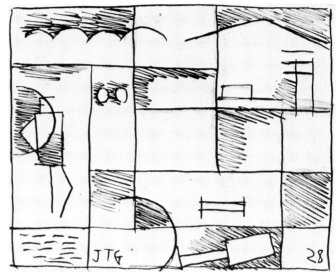

15 **Construction.** 1928

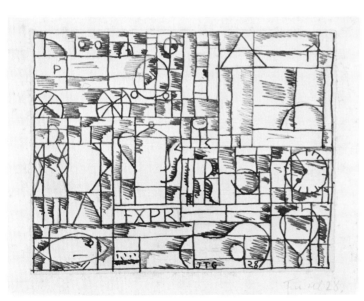

16 **Still life with coffee pot.** 1928

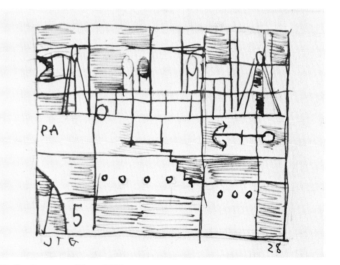

17 **Port composition.** 1928

18 **Neighbourhood scene with boat and harbour.** 1928

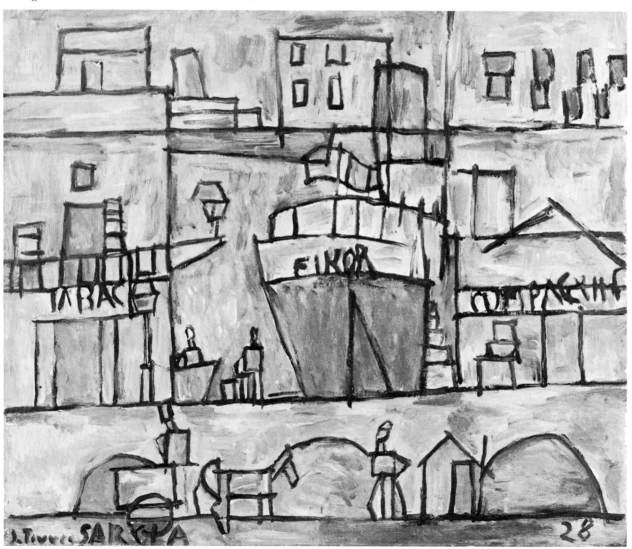

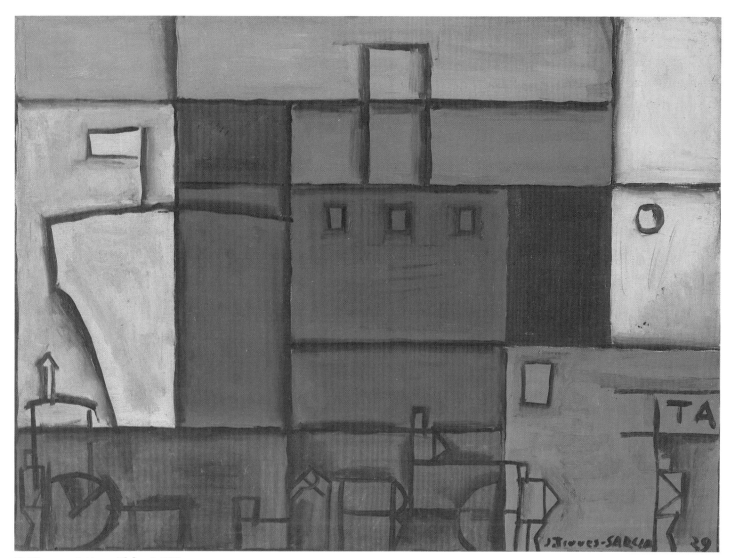

19 **Planar painting with boat.** 1929

20 **The cellar.** 1929

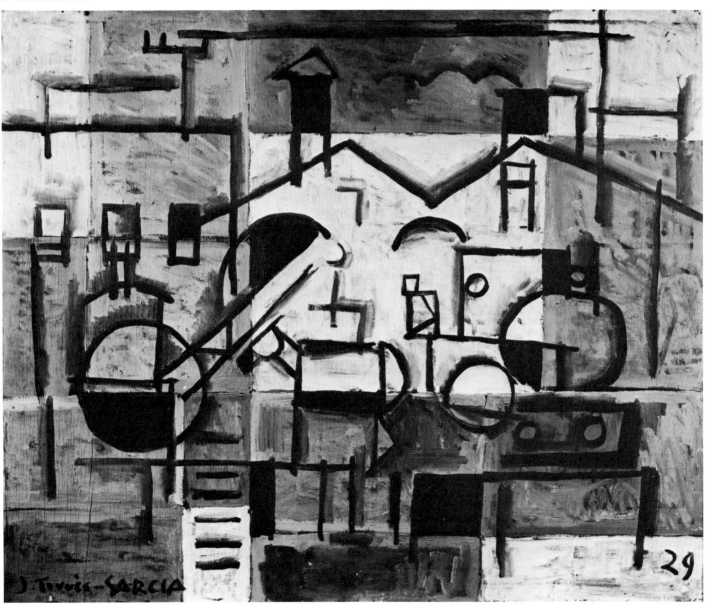

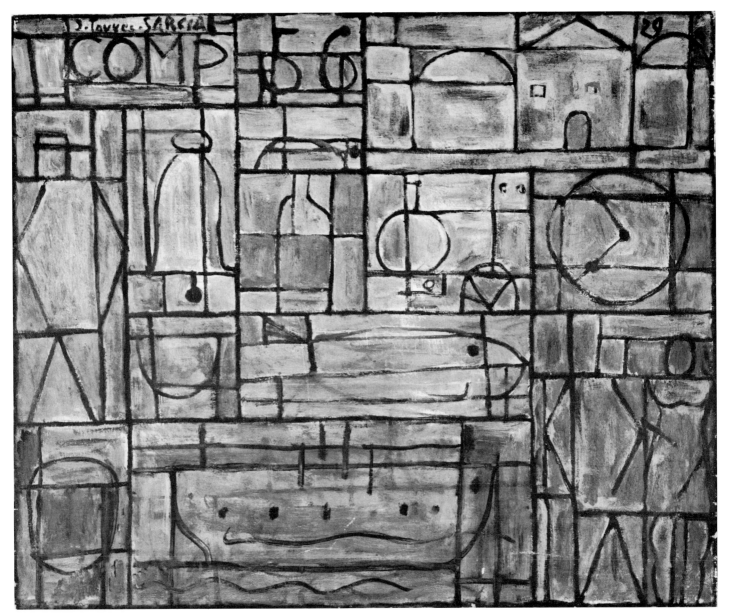

22 **Construction with fish.** 1929

31

21 **Physique.** 1929

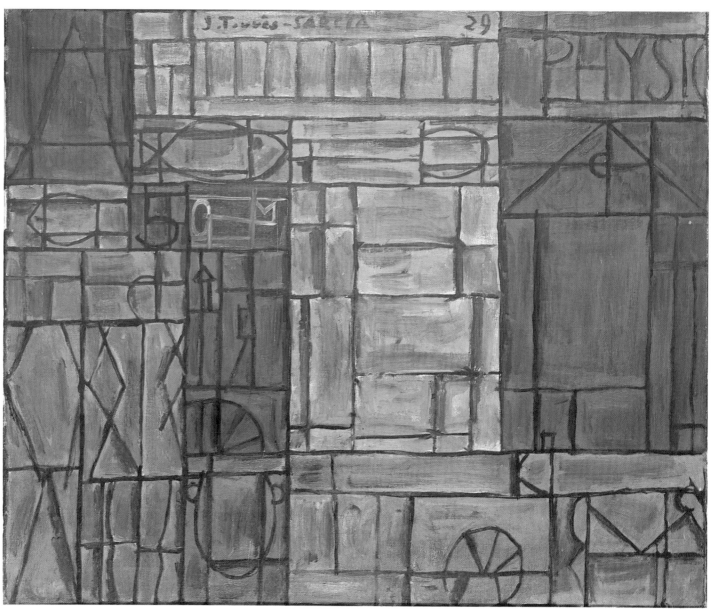

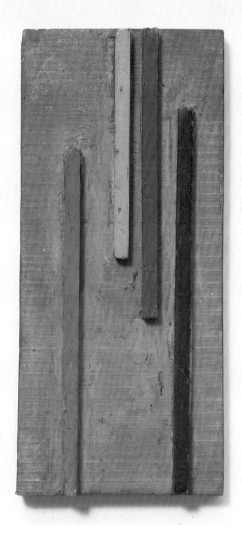

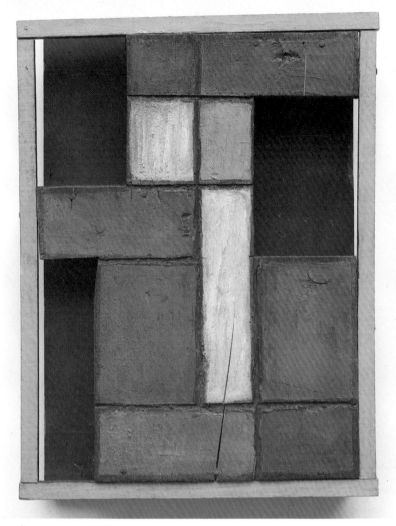

24 **Superimposed rhythms.** 1929/30

25 **Construction I.** 1930

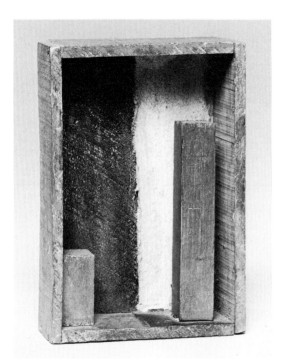

23 **Untitled (box).** 1929

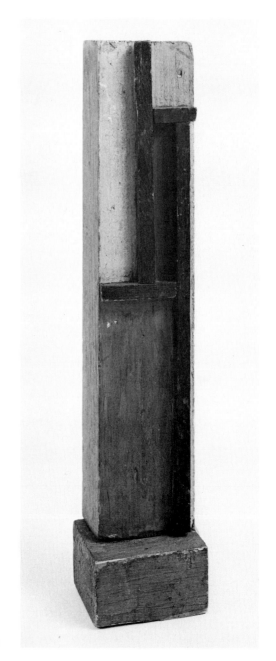

28 **Structure with superimposed planes.** 1930

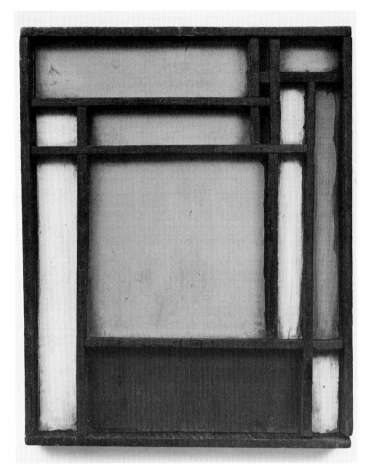

26 **Construction.** c.1930

27 **Construction II.** 1930

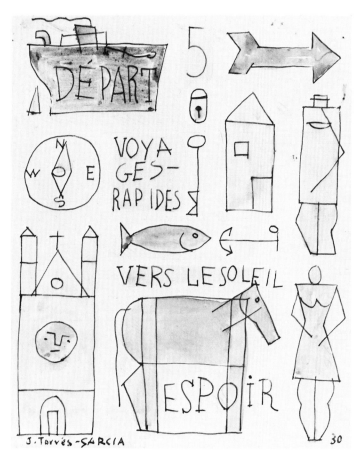

29 **Swift journeys toward the sun.** 1930

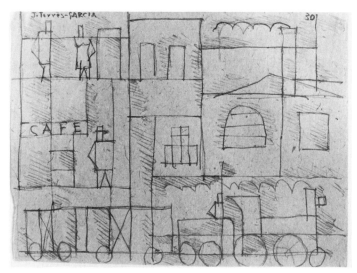

30 **Landscape with café.** 1930

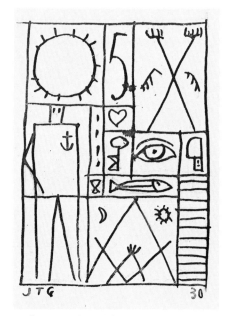

31 **Construction with no.5.** 1930

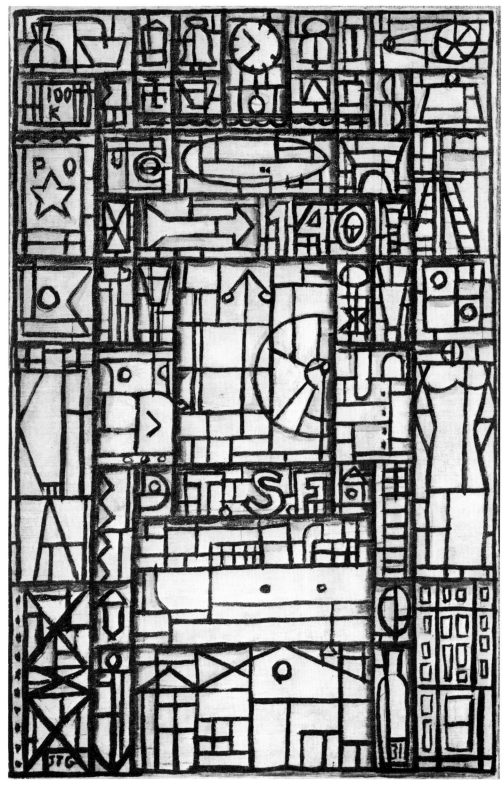

32 **Constructive composition TSF/140.** 1931

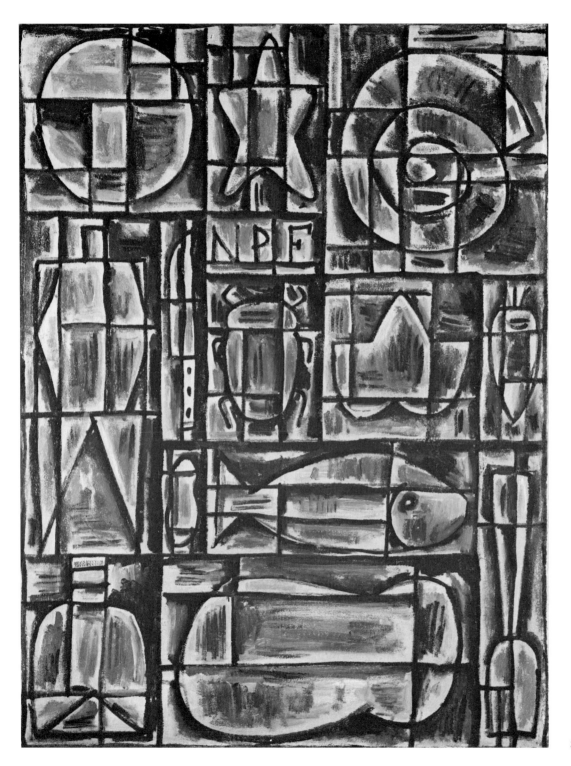

33 **Constructive painting.** c.1931

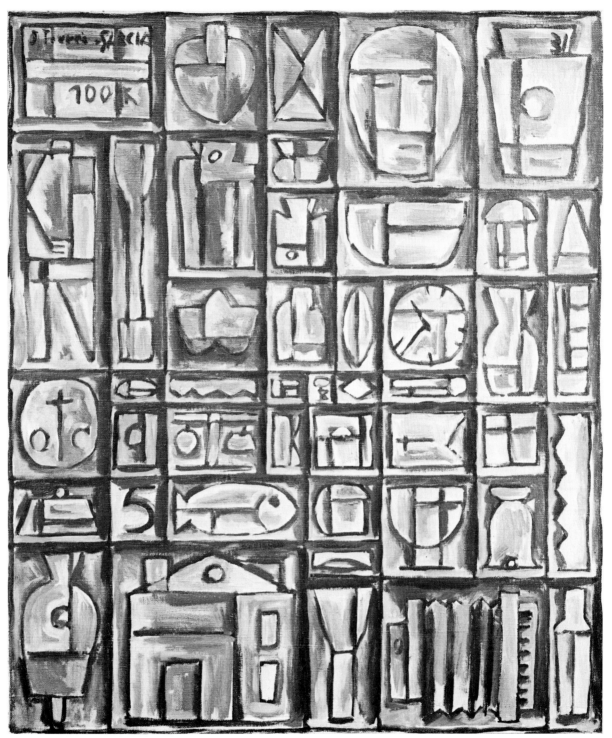

34 **Composition.** 1931

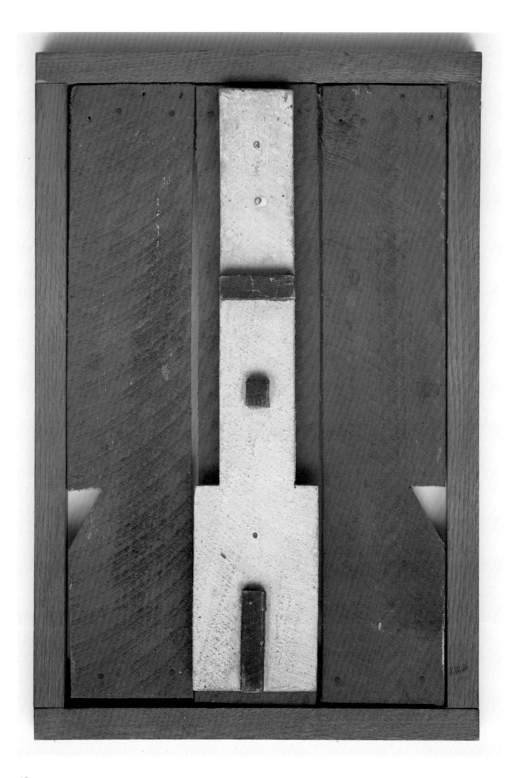

36 **White form superimposed on red ground.** 1931

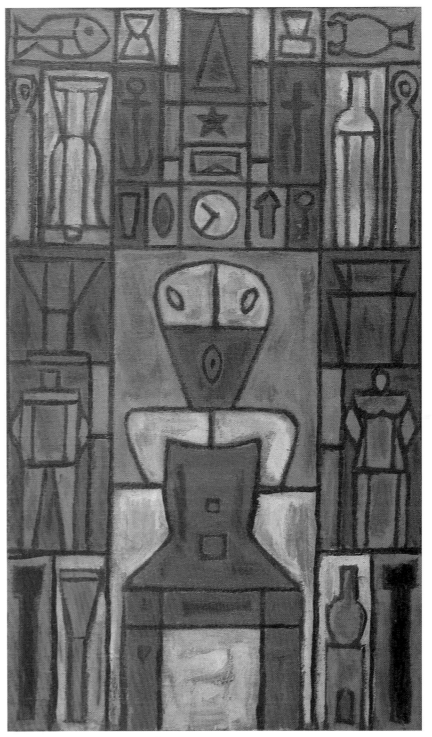

38 **Construction with strange figures.** 1931

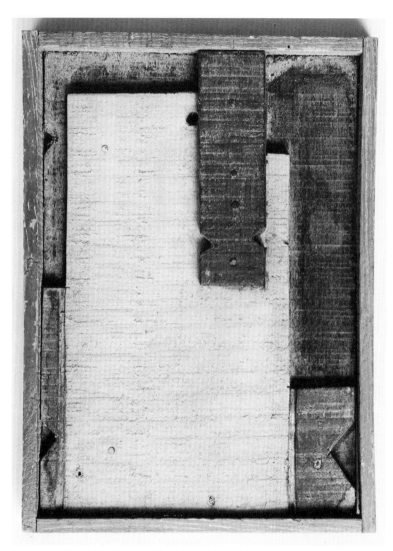

35 **Frame with superimposed forms.** 1931

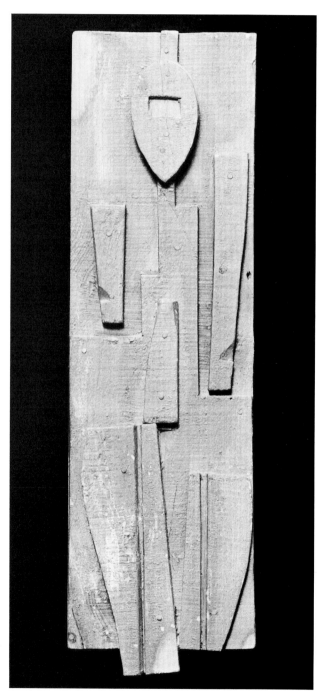

37 **Figure in red.** 1931

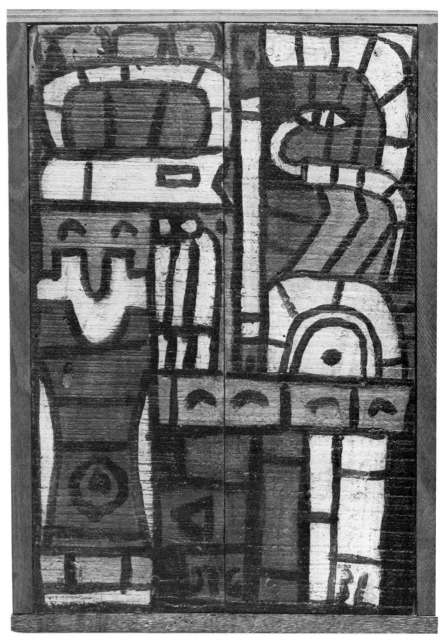

39 **Construction with serpentine forms.** 1931

41 **Untitled.** 1932

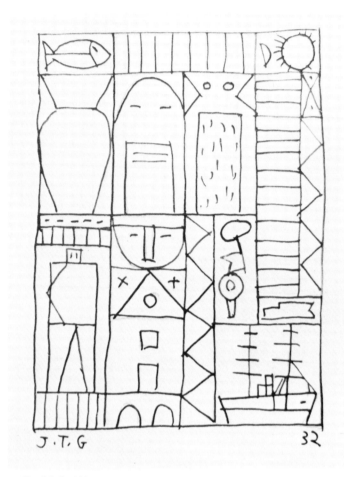

42 **Untitled.** 1932

43 **Construction: Sagesse et justice.** 1932

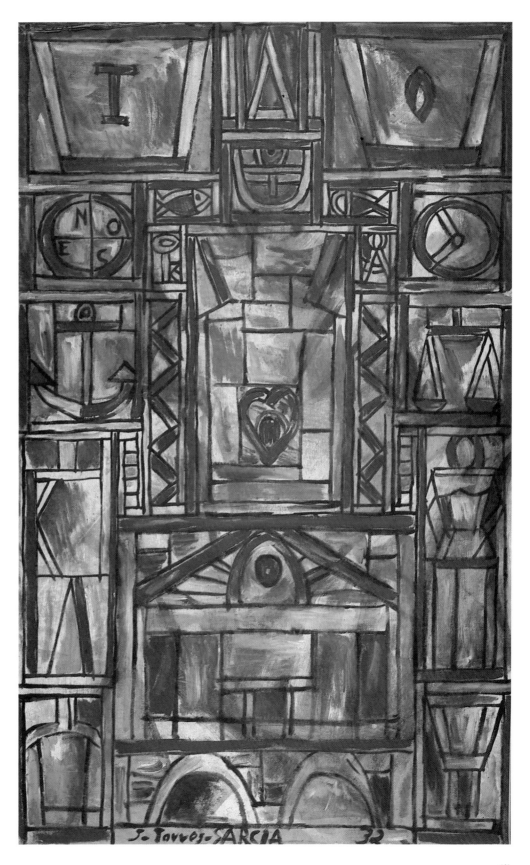

40 **Symmetrical composition in red and white.** 1932

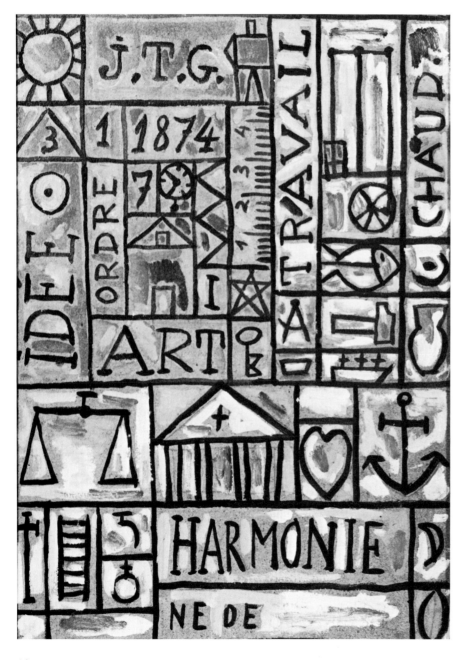

44 **Constructive graphism in three colours.** c.1932

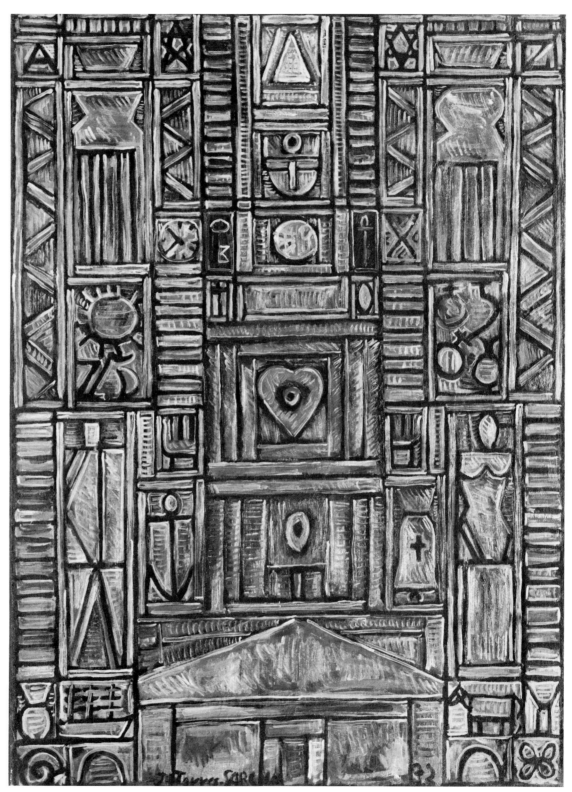

45 **Composition with temple pediment.** 1932

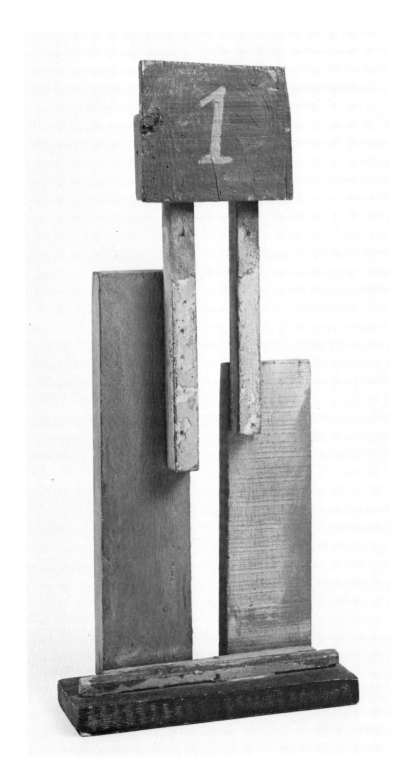

46 **Object with no.1.** 1932

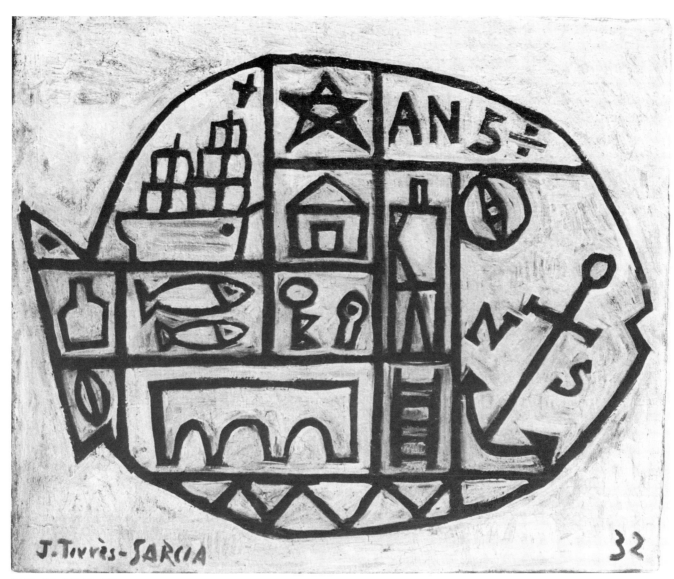

47 **Untitled (fish).** 1932

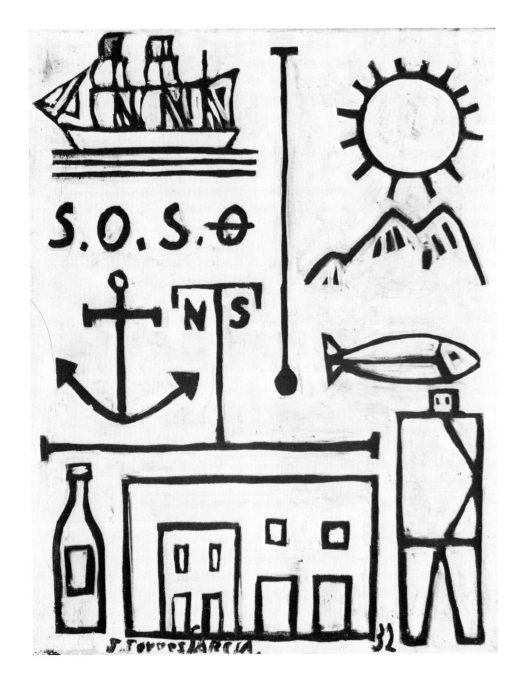

48 **Graphism in white and black.** 1932

49 **Untitled.** 1932

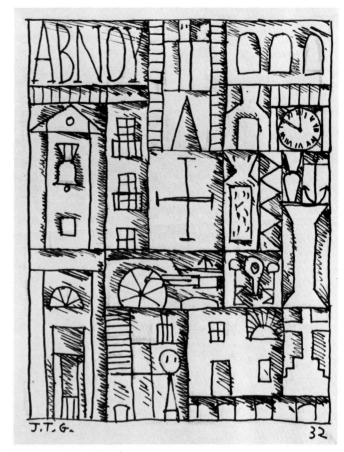

50 **Composition ABNOY.** 1932

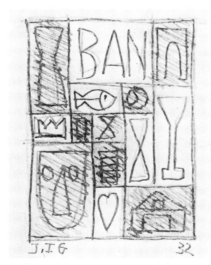

51 **Constructive composition BAN.** 1932

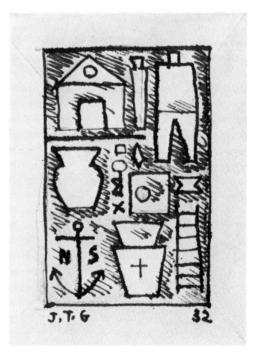

52 **Composition/structure.** 1932

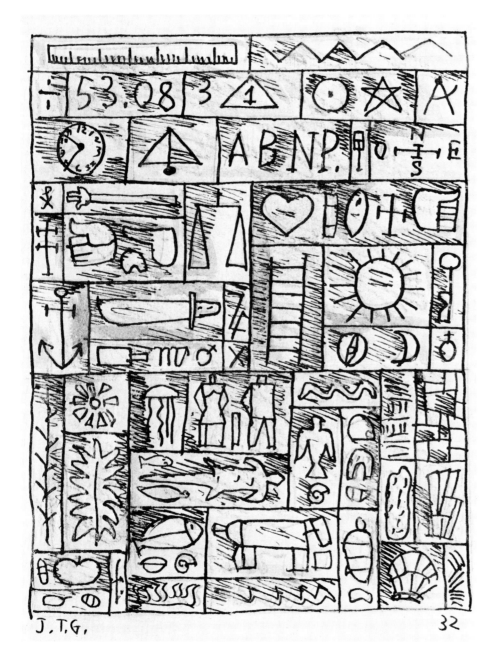

53 **Composition/structure: Elements of nature.** 1932

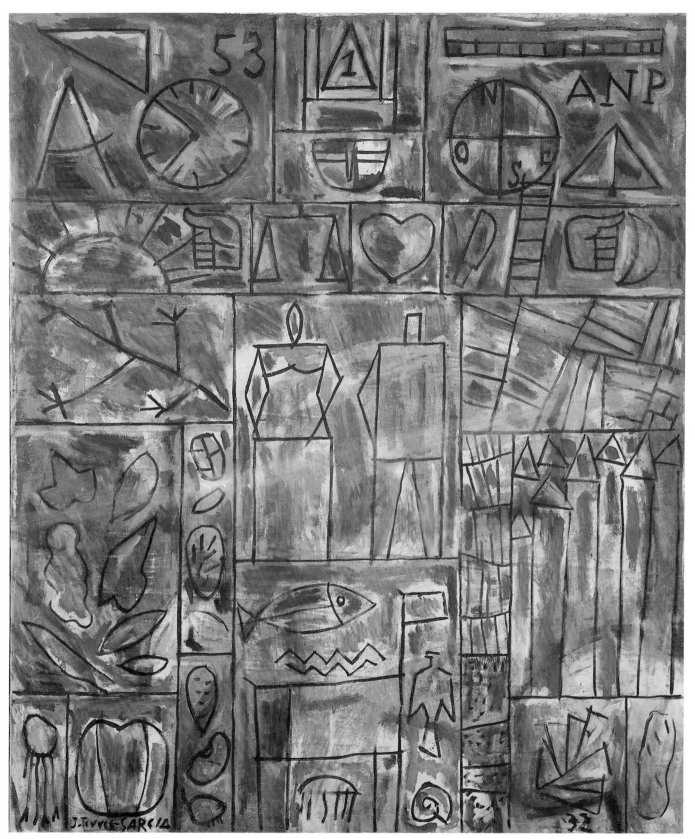

54 **Universal composition: Elements of nature.** 1932

53

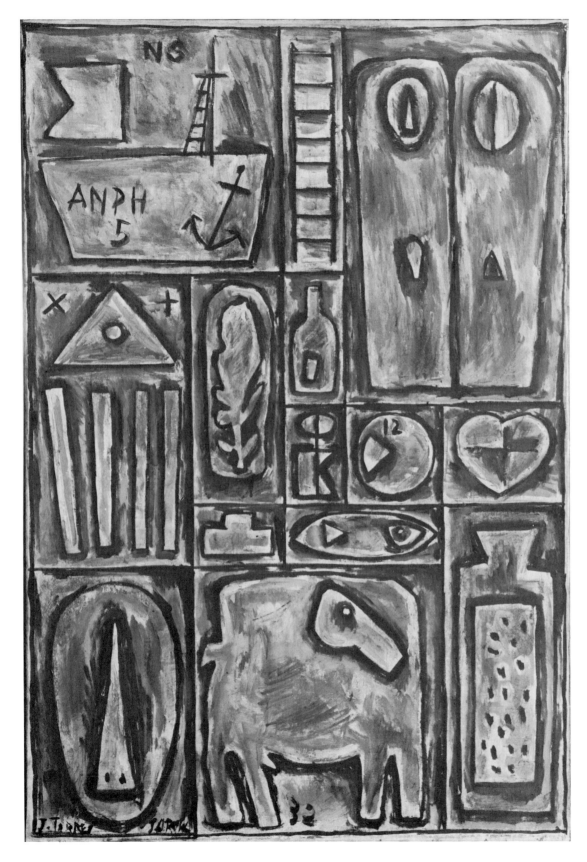

55 **Composition with primitive forms.** 1932

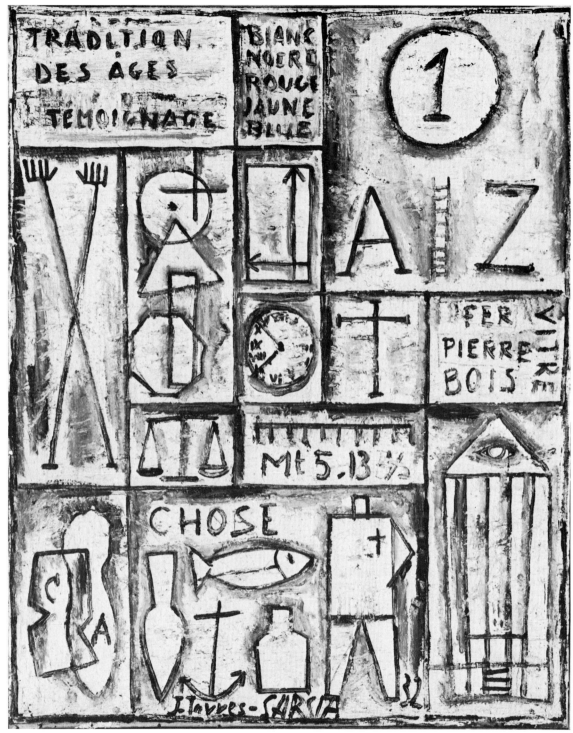

56 **Universal composition: Tradition of the ages.** 1932

57 **Constructivist composition.** 1933

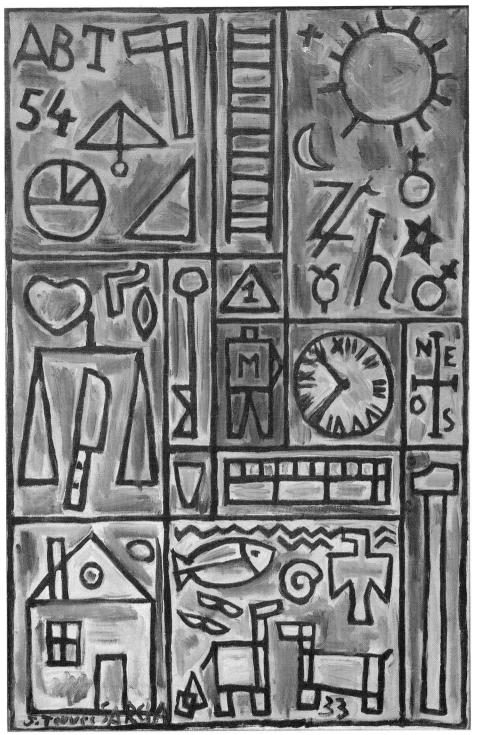

59 **Construction in black, with grey ground and red centre.** 1933

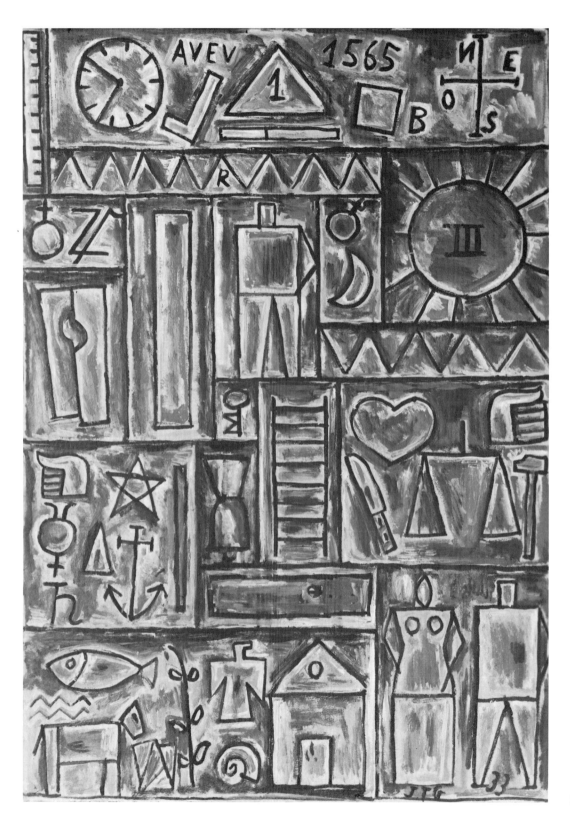

58 **Untitled (AVEV).** 1933

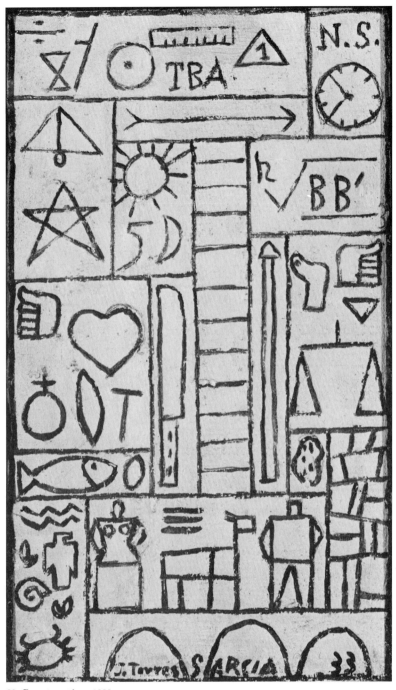

60 **Construction.** 1933

62 **Planes of colour.** 1933

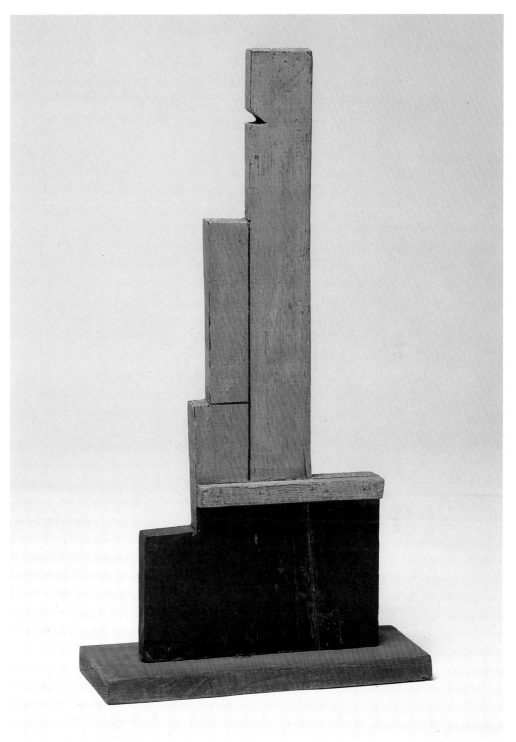

65 **Form in black and white.** 1932

61 **Planar construction.** 1932

64 **Vertical construction.** 1933

63 **Composition.** 1933

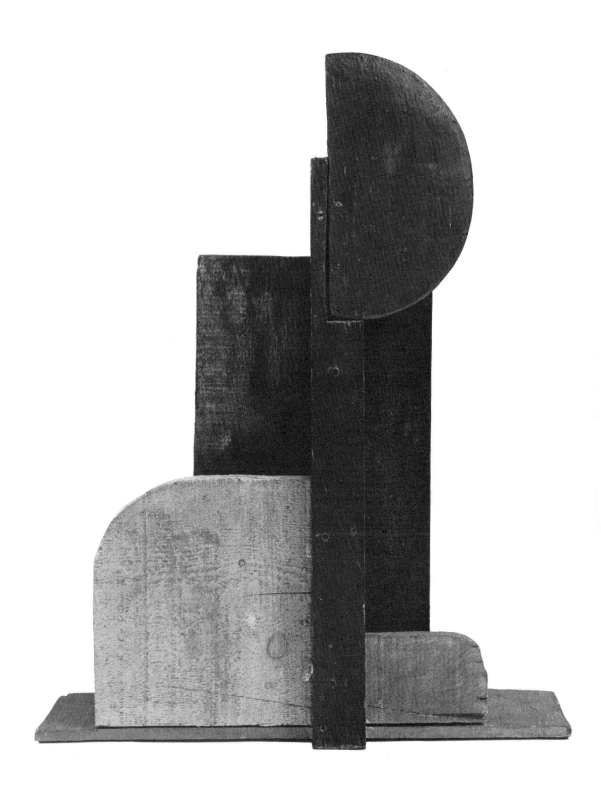

66 **Composition.** 1931–4

67 **Intersecting forms.** 1933

68 **Intersecting forms.** 1933

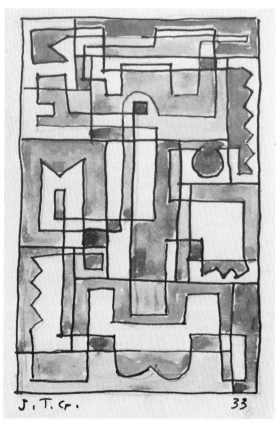

69 **Treated forms.** 1933

70 **Intertwined psychic forms.** 1933

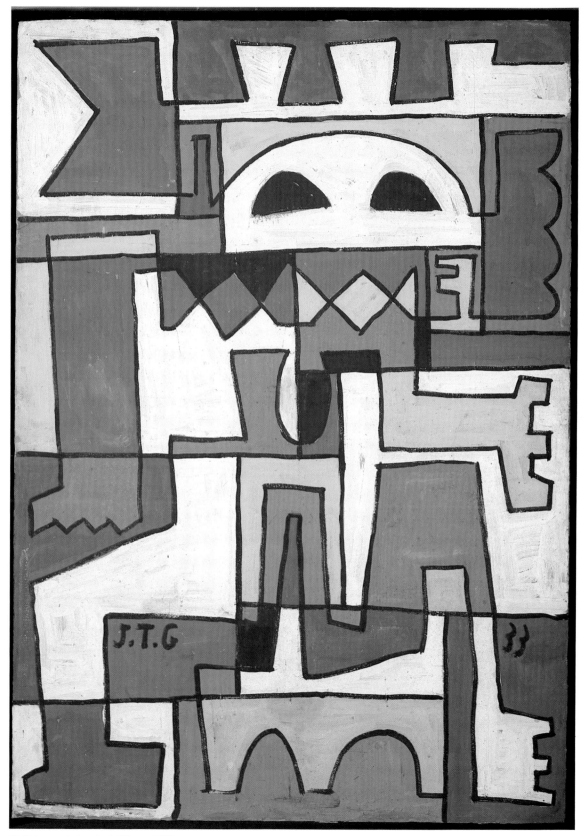

71 **Intersected animist form.** 1933

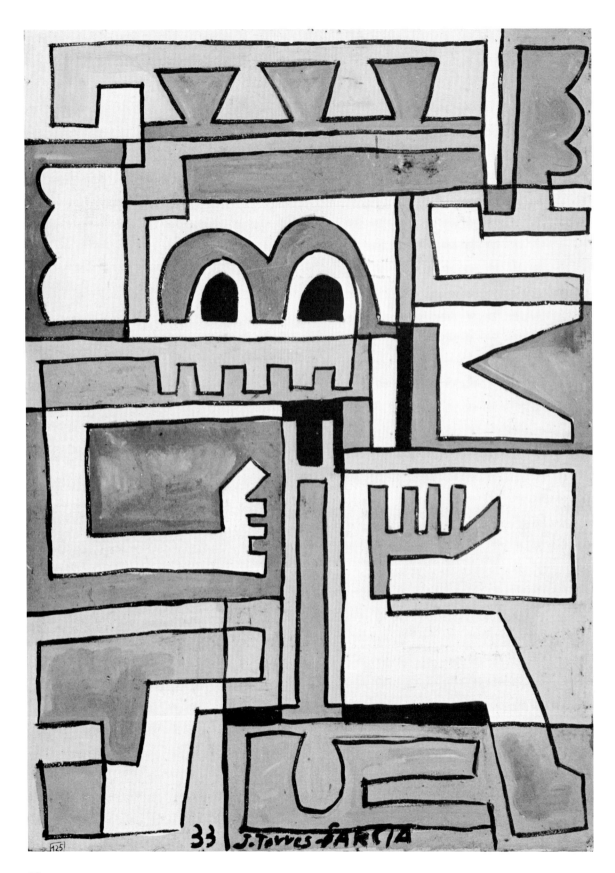

72 **Assembled animist**
forms. 1933

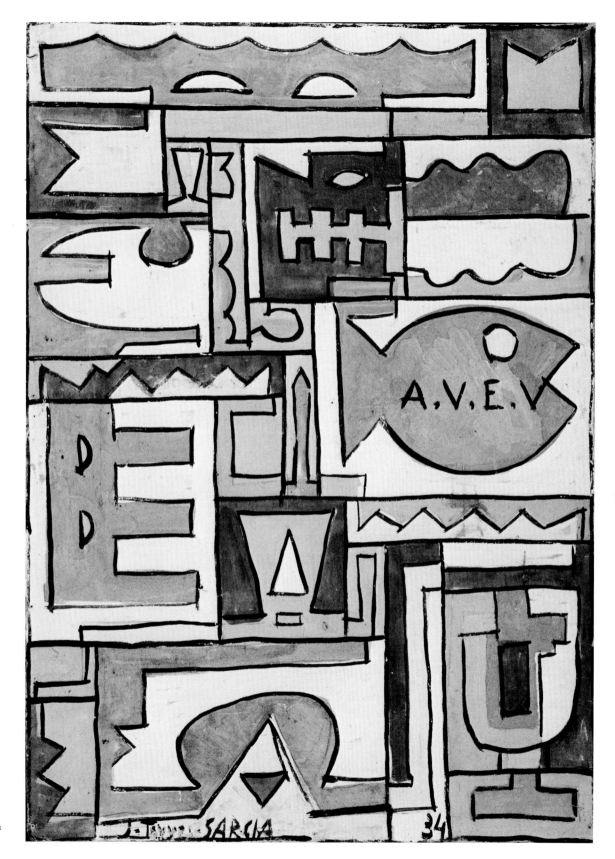

74 **Forms divided by a structure.** 1934

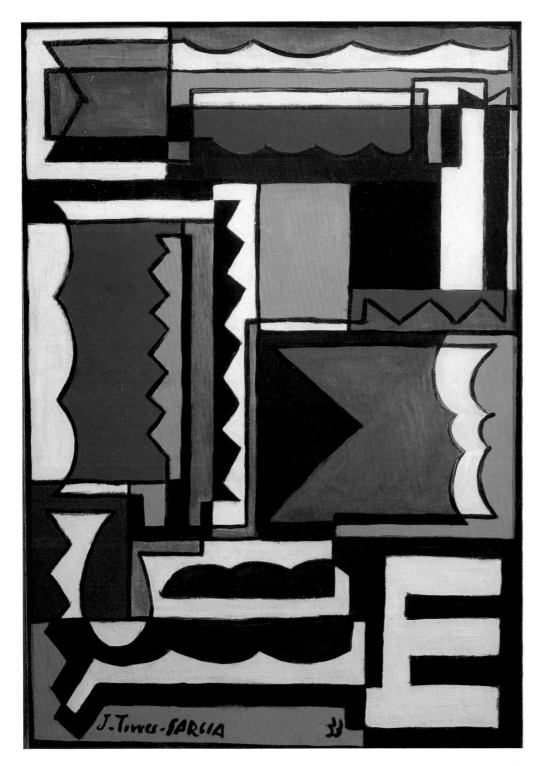

73 **Structure with assembled forms.** 1933

75 **Structure with fish.** 1935

76 **Abstract geometric form with figures.** 1935

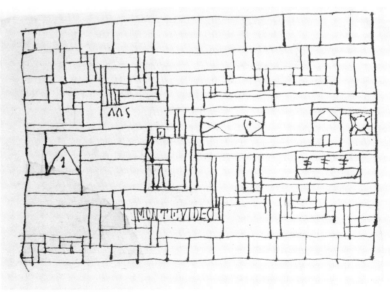

77 **Construction with universal man.** 1935

78 **Abstract composition Montevideo.** 1935

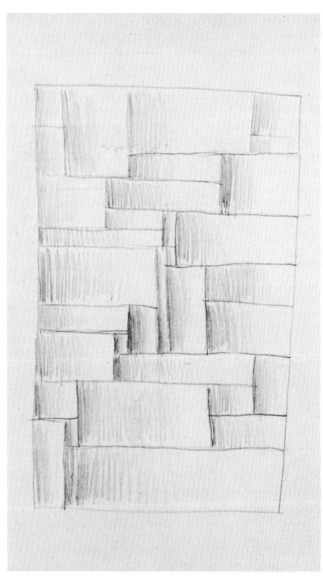

79 **Abstract tubular.** 1935

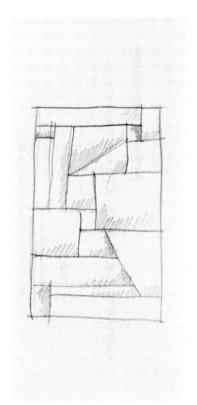

80 **Drawing.** not dated

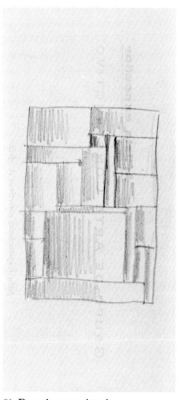

81 **Drawing.** not dated

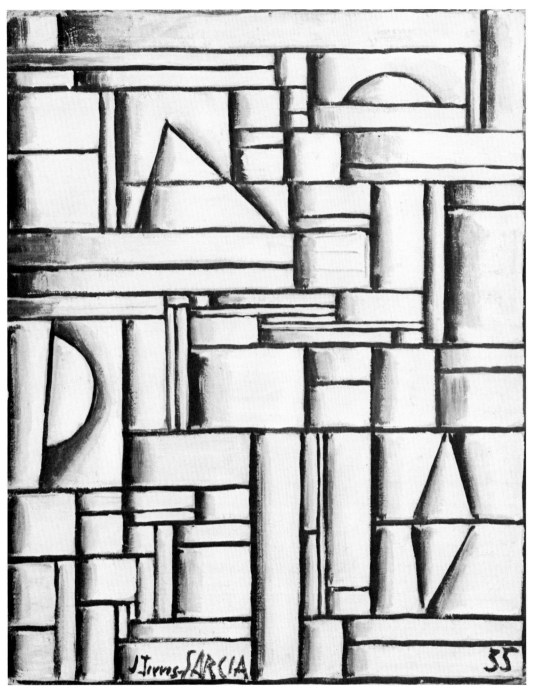

82 **Abstract structure with integrated geometric forms.** 1935

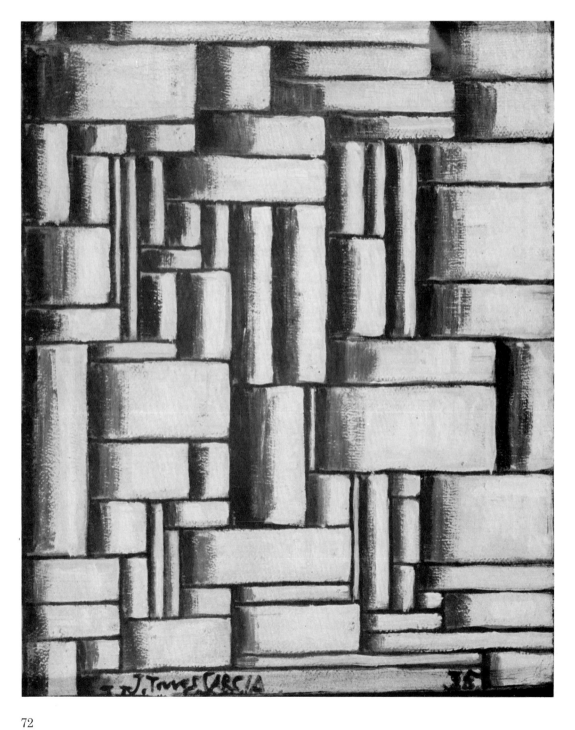

83 **Structure.** 1935

84 **Abstract tubular.** 1937

85 **Study for rhythm with obliques in black and white.** 1937

86 **Tubular composition.** 1938

87 **Abstract tubular with figures.** 1938

88 **Abstract tubular composition.** 1937

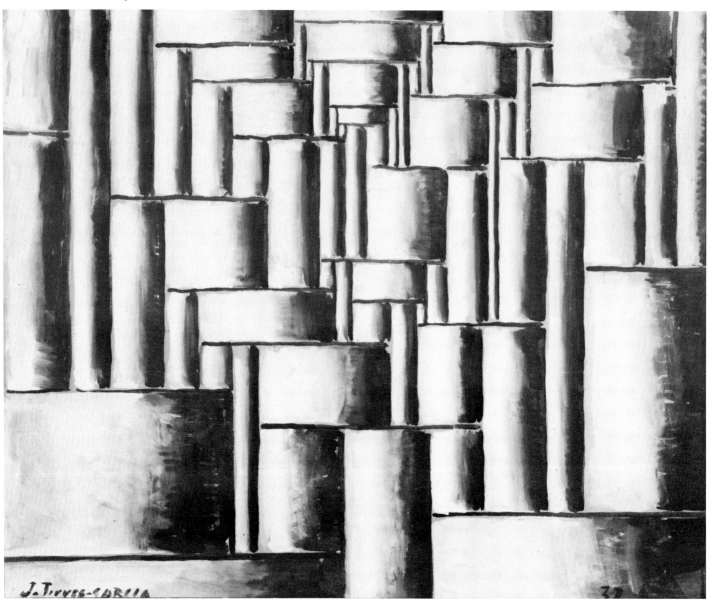

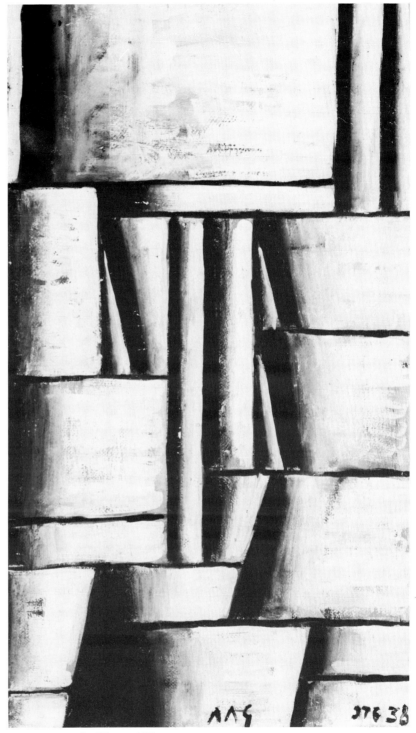

89 **Rhythm with obliques.** 1938

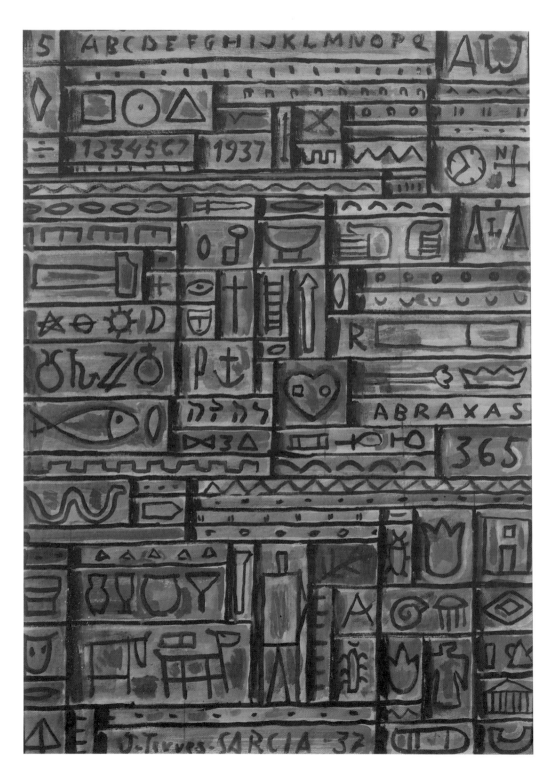

90 **Constructive painting 3.** 1937

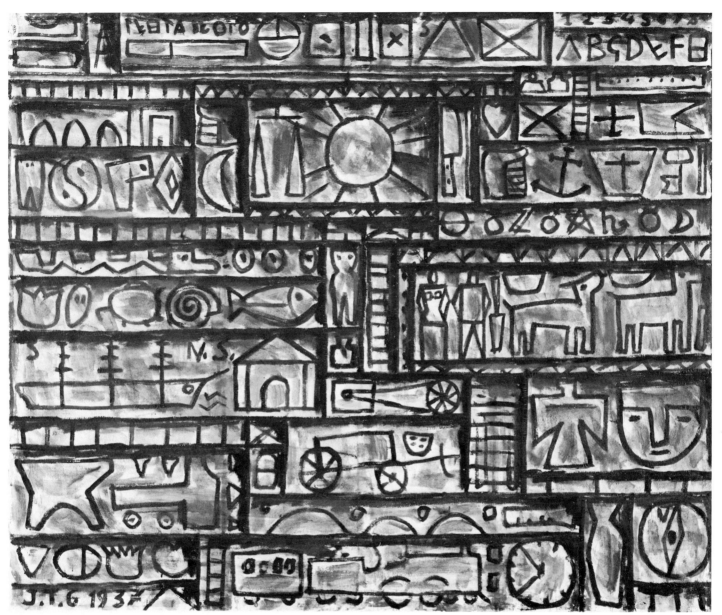

91 **Universal art.** 1937

92 **Constructivist painting in white and black (INTI).** 1938

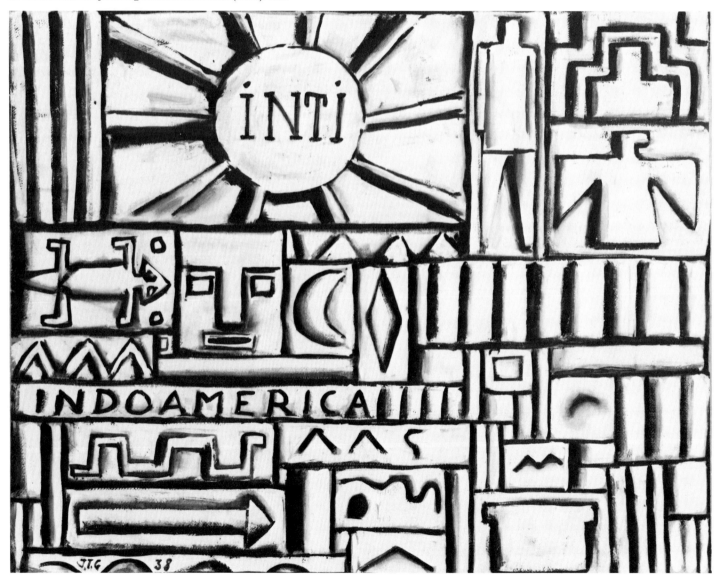

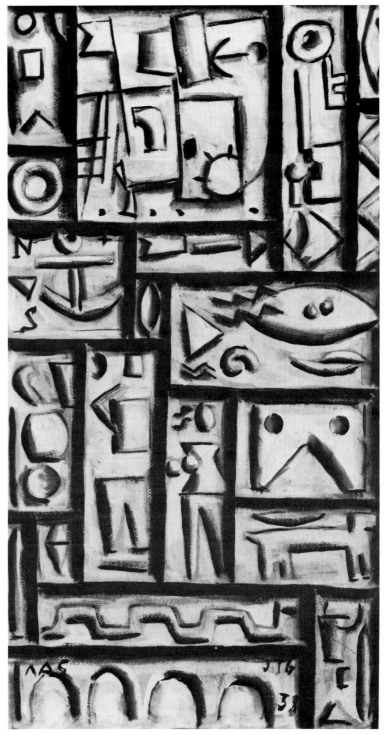

93 **Untitled.** 1938

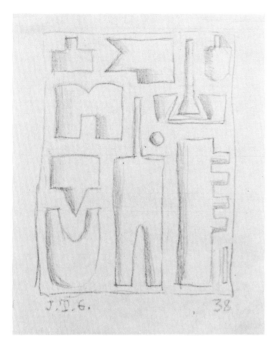

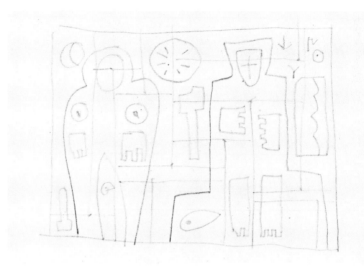

97 **Two abstract figures.** 1937

94 **Artefacts in black and white.** 1938

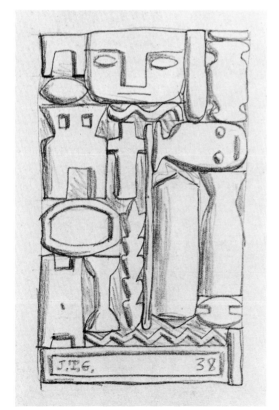

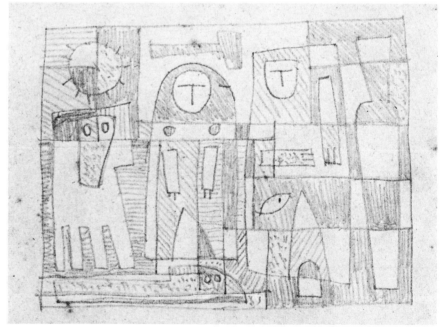

98 **Abstract figures.** 1937

95 **Shaded forms.** 1938

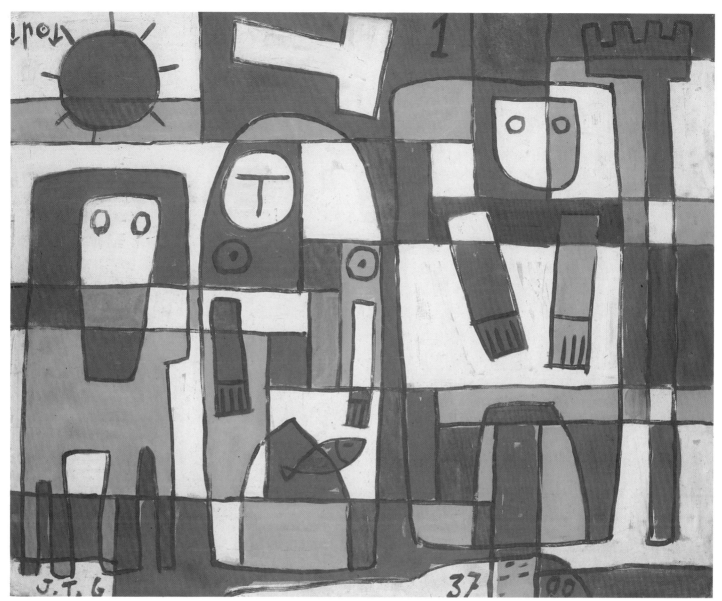

99 **Three primitive constructive figures.** 1937

96 **Composition.** 1938

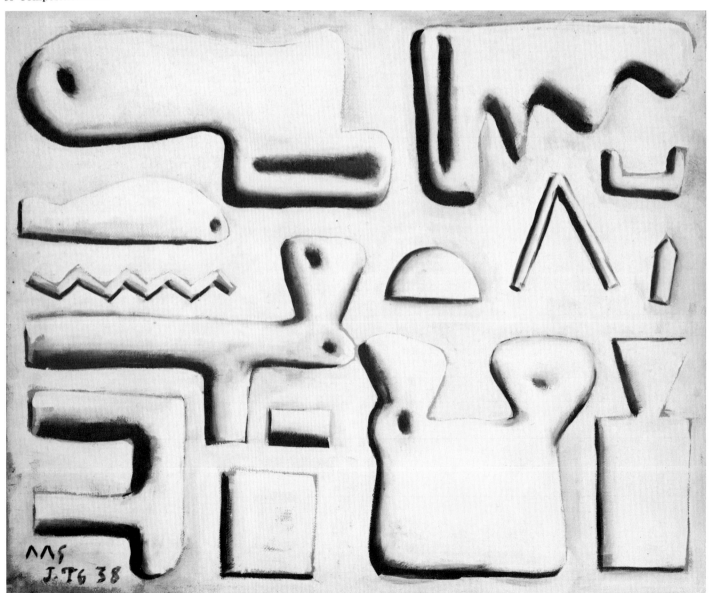

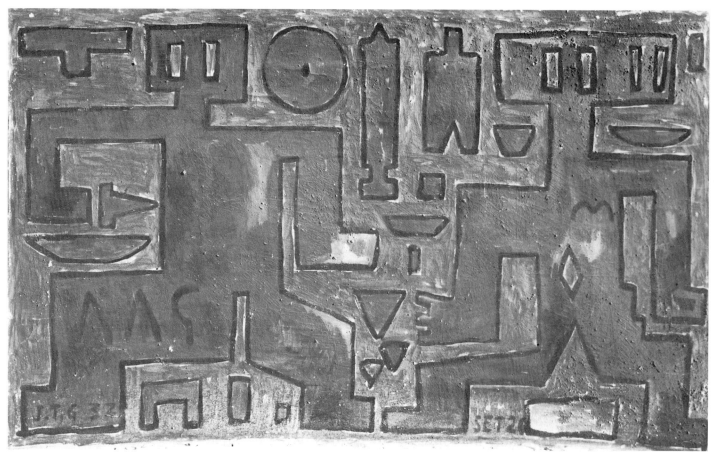

100 **Forms.** 1937

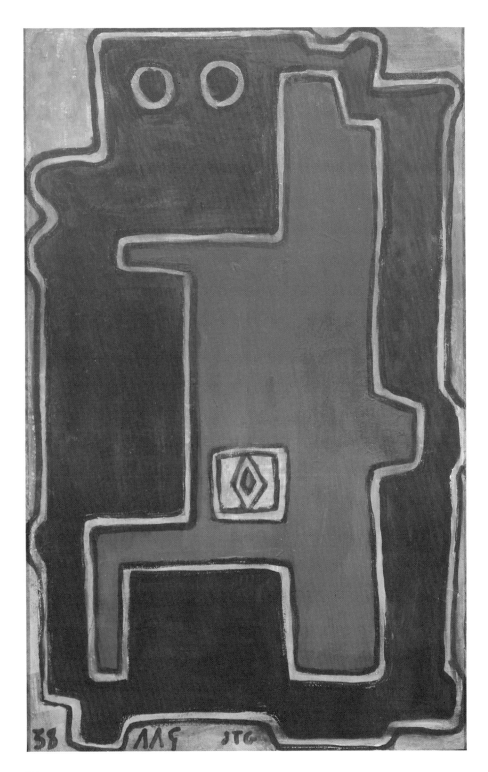

101 **Psychic forms in red and black.** 1938

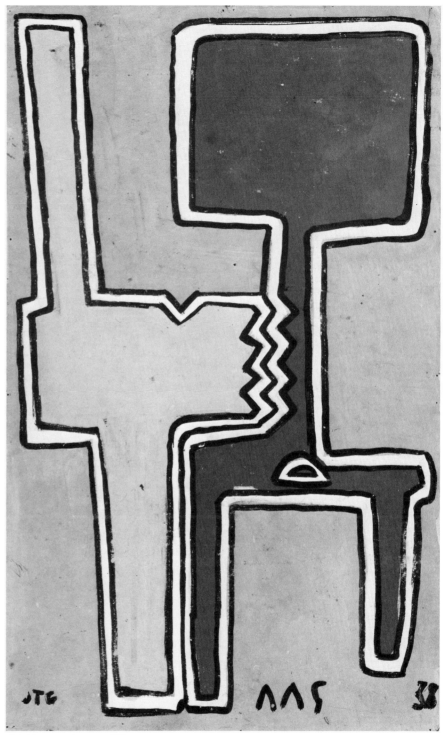

102 **Abstract forms.** 1938

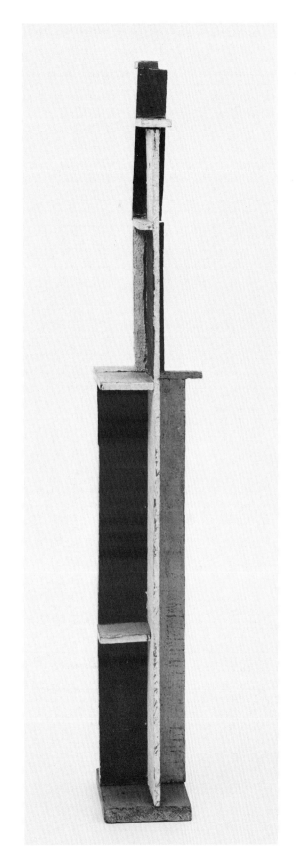

103 **Construction in red and white.** 1938

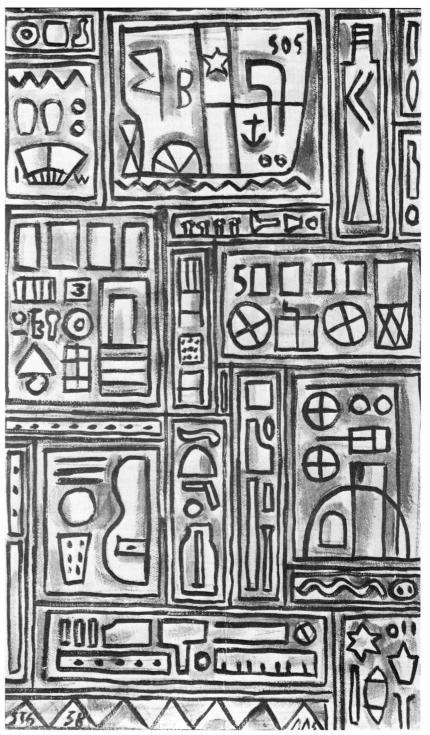

104 **Constructive painting 6.** 1938

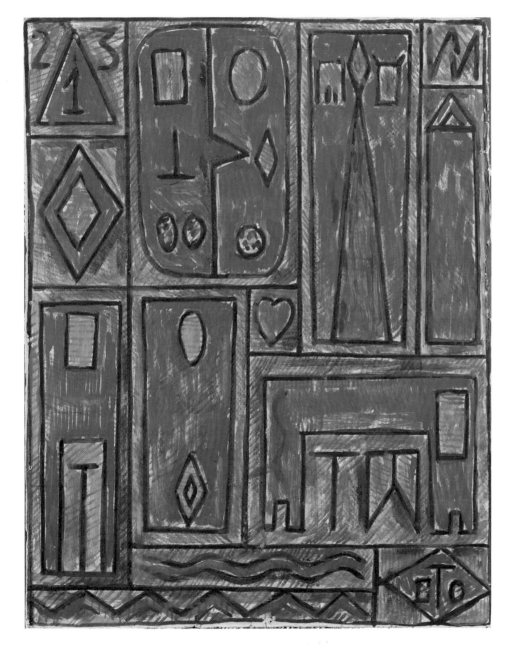

105 **Construction in earth red.** 1938

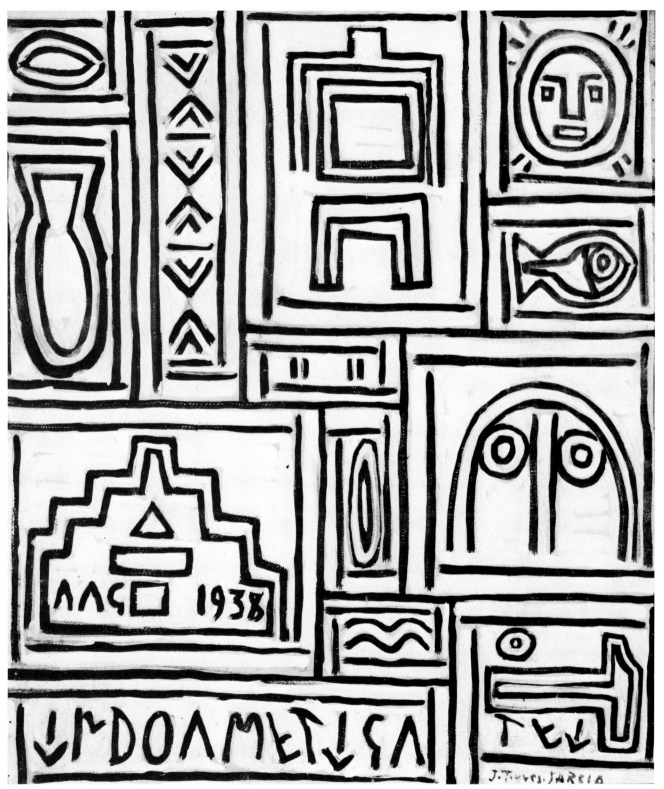

106 **Magic graphism.** 1938

107 **Indoamerica (sun and earth).** 1938

108 **'Teogonia Indoamericana'.** c.1937

109 **Artist art constructivo.** 1939

90

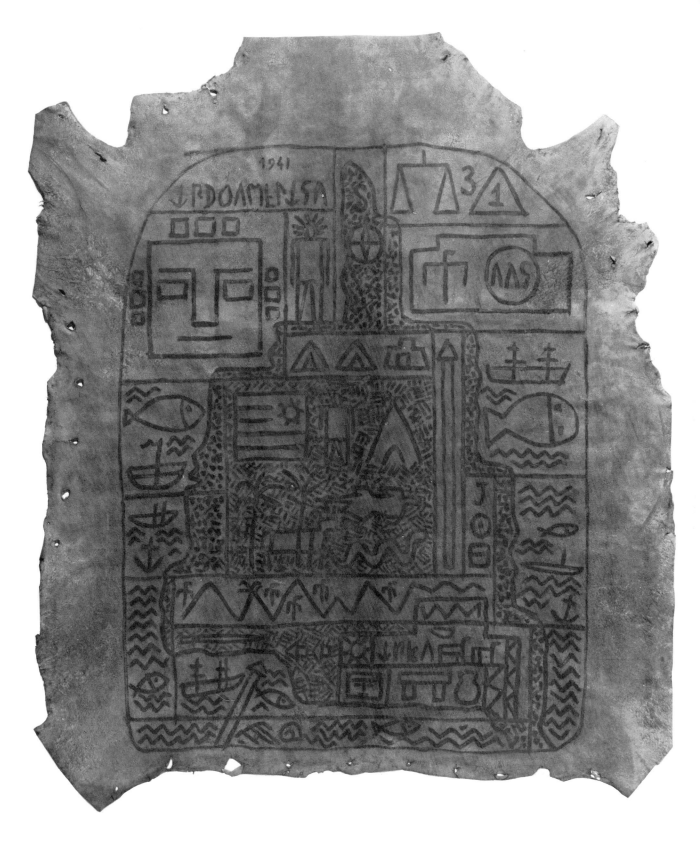

114 **Indoamerica.** 1941

110 **Constructivo AAC.** 1939

111 **Untitled.** 1939

112 **Untitled.** 1939

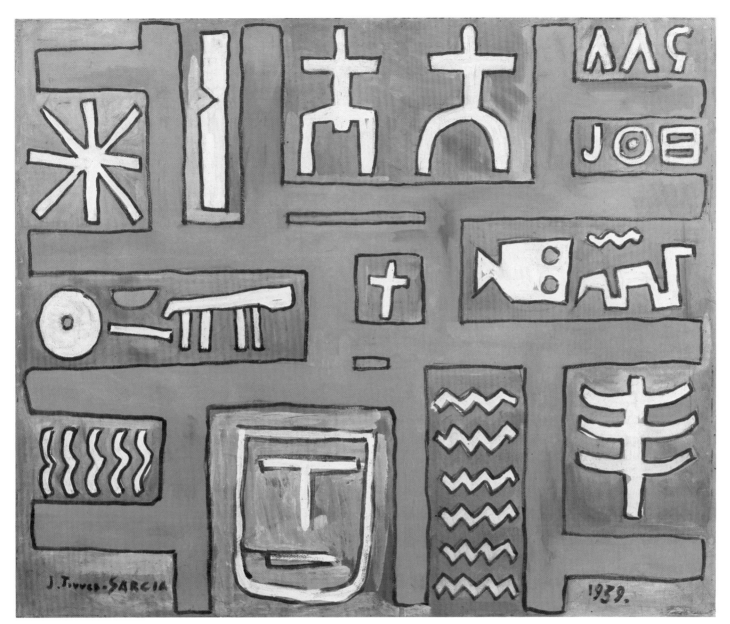

113 **Structure in ochre with white signs.** 1939

115 **Pachamama.** c.1942

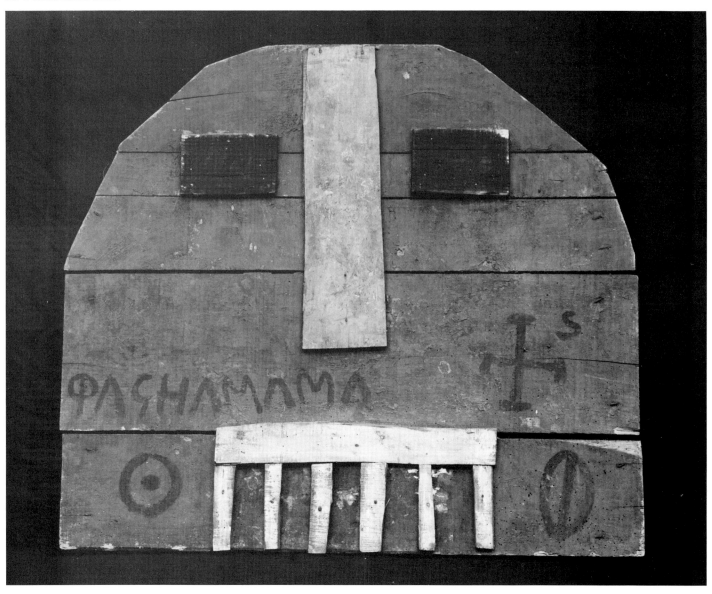

117 **Infinite construction.** 1942

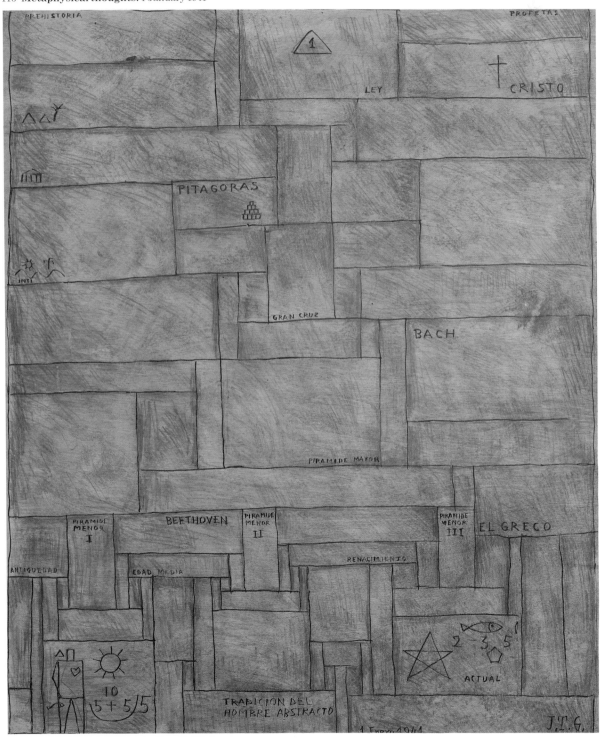

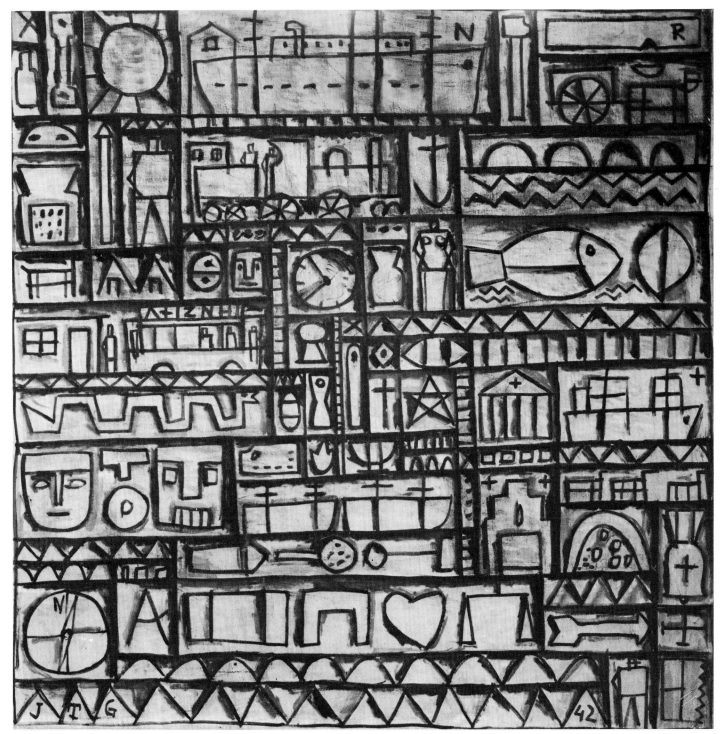

118 **Universal constructive art.** 1942

119 **Constructive painting 12.** 1943

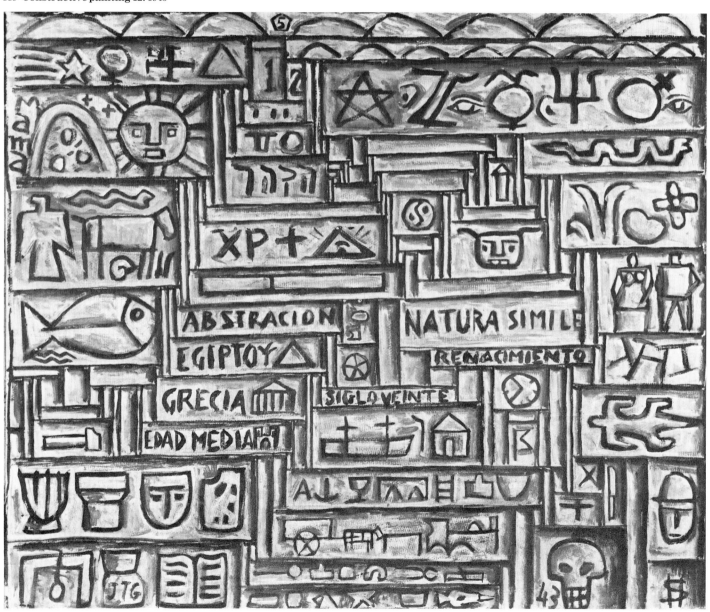

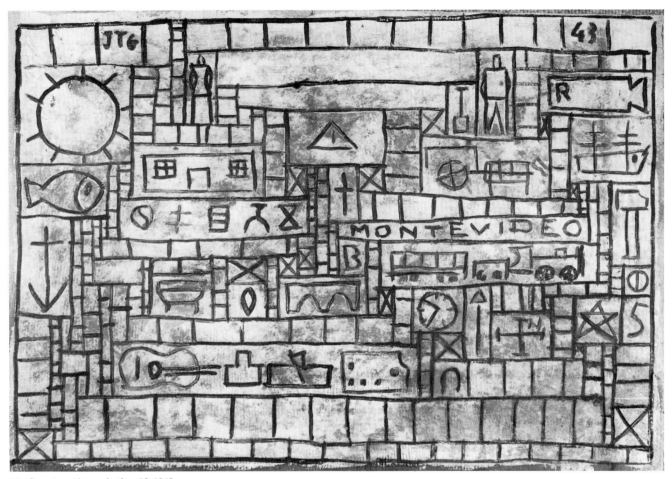

120 **Constructive painting 16.** 1943

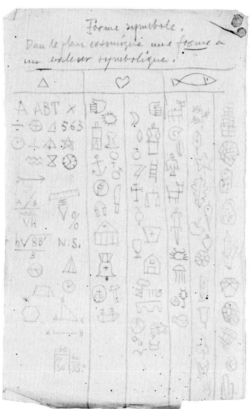

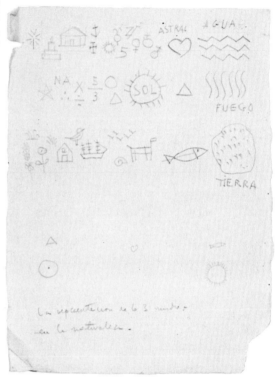

121 **Drawings and symbols.** not dated

Torres-García's Planism

Theo van Doesburg

Spiritual suffering has always been the mark of genius. 'More genius, more cares,' said the German poet Goethe, and that proverb contains within it the whole truth of the spirit's struggle against nature. For it is indeed nature that prevents us from evolving towards absolute perfection; nature is indeed the enemy of all that is pure, serene, immaculate and sacred.

We are mistaken if we accept the idea, which at present dominates every domain of aesthetic activity, that there is a well-balanced link between nature and ourselves, between the physical and the spiritual.

Neo-classicism's assertion that there is a classical balance between the two is no more than a compromise, and it will therefore lead to compromises in painting, poetry and sculpture. Must we accept a compromise?

No. On the contrary, we must mount the horse of imagination and ride through all the abstract heavens in order to find the true and the real.

But to do that, we need muscle. The beast within us must be strong, sinewy and spirited.

As the painter Torres-García says, we must live within the universal.

We are mistaken – and this is the principal mistake of our day – if we believe that the development of mechanical and practical life can replace the inner, spiritual life. Worship of material goods of all kinds has led to a veritable search for novelty (*das niedagewesene!*) and for material perfection. The new god is comfort. Usefulness has become omnipotent. Our gestures are calculated, Taylorized and automated; they obey the petty, perforated souls whose domestic ambitions drive them to electrify water-closets. The man of the future will be as mechanical as a sewing machine.

It is against this spirit – or lack of spirit – that we take our stand, but our protests do not mean going back to the hansom cab or taking refuge in dreams – the safety valve used by feeble masturbationists who create a urinary atmosphere around them.

No thank you! We are above all disinterested realists, *realists* from the other side if you wish, but we are r-e-a-l-i-s-t-s and realizers.

We are neither *passéistes* nor futurists because our watches have stopped at zero. As Torres-García says, 'There is no time, no space, no matter. There is no relationship between things, no separation. Far away from any fatherland, there lies the universal, the place where art, science, religion are one and the same.'

We are against the 'modern' just as we are against the 'ancient' because we met at the spiritual calvary. Quite simply, we met within the universal.

That is the palette which Torres-García uses.

Painting has become a new scourge, a cruel epidemic raging through the great cities of Europe. It is particularly harsh on Paris, where painters form a compact mass of mediocrities, brigands, *arrivistes* and somnambulists. It is out of pure snobbery that a few unhealthy ambitions and ephemeral conjuring tricks are sold at auction. Once you have fallen into this stinking mire of mercantilism, there is no escape.

Those who once made a profit out of a few noble ambitions and a few great personalities (Cézanne, Van Gogh, Modigliani, etc.) who risked all and won nothing, who sacrificed their lives and displayed their white, naked souls on a few decimetres of canvas, are once again crushing the five or six humble painters who create because they feel an inner need to do so.

Obviously, there are many painters and very few creators. Torres-García is one of the latter, a creator and a man.

He is a painter of great stature and he inscribes his pic-

torial vision in matter, a light, almost transparent matter which is his alone, a simple and delicate matter. His technique has none of the irritating sensuality one finds in the false fauves or the semi-cubists.

The art of Torres-García consists of pure elements. There are no complications, no trick effects, and there is no confusion.

His art is dominated by planes supported by lines, and the juxtaposition of the two gives the plane-surface a *rhythmic inscription*. The rejection of all *description* and of all literary or symbolic tendencies is the hallmark of the thoroughbred painter. This is why Torres-García's art successfully avoids the cerebral or somnambulistic temptations that are so marked in the work of the fashionable dreamers. In true painting, like that of Torres-García, everything can be expressed and understood in terms of composition and purely pictorial means. This conception, which has been shared by true painters of all periods, will eventually lead to constructive painting, to *scientific painting*. In the future, a painting will have its own immutable laws and will be constructed with as much certainty as a bridge, a skyscraper or a boat.

As our intuition and science develop, the artist will come to know new dimensions and, with the help of a new perspective, it will be possible for him to make visible a broad vision of our unconscious. This perilous leap into a new dimension is not without its dangers. First, we must rid ourselves of the whole inventory of antiquity. Oil lamps will be of no use to us in our clean white interior. The petrol engine has killed the horse. The brown, bituminous painting of the Renaissance gave way to the blue painting of the luminist period. White painting will be the third phase of pictorial development.

It has already seen the light of day with the elementarist painters, and it is no accident that it should have been the two greatest pictorial cultures (that of Spain and that of Holland) which introduced these new tendencies in contemporary painting. It is probably because of this logical development in the work of all thoroughbred painters that they are so similar, even though they work in different scales and different styles.

Whereas cubism reconstructs objects in terms of pictorial intuition, Torres-García expresses his plastic intuition immediately and spontaneously by using colour-planes and elementary lines.

Painting the more or less deformed or transformed objects (the degree of deformation and transformation depends upon the degree of creative motor power) that are now accepted by art collectors and critics means remaining within the gravitational field of a Euclidean world. Paintings serve only the spirit. Oscar Wilde understood the meaning of painting when he said that: 'Art finds her own perfection within, and not outside of, herself. . . . The more abstract, the more ideal an art is, the more it reveals to us the temper of its age.' [1]

Creating with no intermediary but the means specific to painting gives us the only freedom worthy of the universal spirit. At this stage of plastic expression, we go beyond the world of things that can be weighed and measured. Structure and structure alone sustains the painting.

Only the aristocrats of the spirit can reach the summits where the air is pure and clear.

Torres-García is one of those artists who dare to paint free of prejudice and free of tendencies, as simply as I smoke a pipe of tobacco.

Surrounded by an almost metallic ambiance, he lives in an atmosphere of creation. To watch the painter at work in his studio in Montmartre is to discover a creator. He touches dead things and ordinary materials, and they come to life.

He places before you a small sculpture in painted wood or a simple toy he has created, and they seem to breathe in some miraculous fashion.

He combines these small three-dimensional objects with his plane-paintings, and a new world opens up, an intimate world of human creation.

You are in close contact with a spiritual environment in which everything partakes of the promorphic atmosphere of creation.

Thoroughbred that he is, Torres-García always creates with vibrant spontaneity. He crossed the dry, monotonous prairie of archaism (c.1902–1915) and came to the electric current of the modern, where the signs read 'Keep Out', 'Danger. High Tension', 'Go Back'. Without letting himself be frightened, he set off towards the truth, towards a form of painting that is simple, pure and real.

And that is where we find him now.

Torres-García sings in minor keys. The dominant key in his painting is made up of three colours: a warm brown, a phosphoric green and the black of nothingness.

That is the triangle of his painting and the trinity of his plastic religion.

Paris, 13 May 1929.

Translated by David Macey

[1] Oscar Wilde, 'The Decay of Lying' in *Selected Essays and Poems*, Harmondsworth, Penguin, 1954, pp.73, 81.

The Tradition of Abstract Man

Joaquín Torres-García

An introduction by Cecilia Buzio de Torres

In 1938 when Torres-García wrote The Tradition of Abstract Man, *he had been living in Uruguay for four years. He had returned from Europe to his native country after an absence of forty-five years. In Montevideo, he soon realized that the artistic atmosphere was conservative and provincial but that young artists were eager to learn about the latest art developments in Paris. He formed AAC (Association of Constructivist Art) in 1935 and, in 1944, the* Taller Torres-García *(Torres-García Workshop). There, constructivist art as well as traditional methods of drawing and painting from the model were taught and studied.* The Tradition of Abstract Man *is the result of the teaching and lecturing that Torres-García did during this period. It is a condensed account of his essential ideas.*

In 1900 as a student at the Academy of Fine Arts in Barcelona, Torres-García had searched for a way out of the stifling academic and decorative styles popular among young artists there. His discovery of the work of Puvis de Chavannes together with studies of Greek philosophy and literature led him to define the basic ideas that would guide his work throughout his life.

In his work and writings Torres-García was always searching for a perspective that would be classic and timeless. The meaning that he attached to the word constructivist is quite different from that used when describing Russian or other constructivist work. For Torres-García Constructivist Art started with cave paintings, when for the first time men represented the world around them in an ordered way. He regarded all great art from that time on as constructivist because of its underlying structure.

Torres-García's concept of Abstract Man, spiritual man, is derived from Hellenism, which for him embodied the highest human ideals in all the arts as well as in philosophy. Particularly important for him was the Protagorian idea that 'Man is the measure of all things'.

In this translation I have endeavoured to maintain the artist's rhythmic use of words and short staccato phrasing; the syntax is not always grammatically correct.

Torres-García wrote and published many texts; The Tradition of Abstract Man *is perhaps the closest to a summary. It was published in a facsimile of his own handwriting; the size of words and the use of capital letters are evidence of the importance he gave to a particular word or idea.*

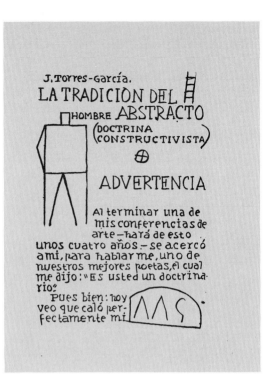

J. Torres-García
THE TRADITION OF ABSTRACT MAN
(CONSTRUCTIVIST DOCTRINE)

NOTE TO THE READER

At the end of one of my lectures on art – four years ago – one of our best poets approached me and said: 'You indoctrinate people.'

Today I can say that he was perceptive in realizing that what I was saying expressed a 'doctrine'. He understood this before I did myself.

While I am in the process of compiling fragments from my lectures, I think it is useful to make this clear: that independent of art in general, at the base of 'constructivist art' there is a doctrine. That is to say it is founded in something well defined, that comes before it and that stands on its own independently. However, I must also specify that this doctrine originated in artistic speculation and that is why it is indissolubly linked to art. This is Constructivism.

Constructivist doctrine is only intended for artists. I would prefer that it not be considered by philosophers, art historians, poets or musicians.

Artists have to be warned that without a thorough understanding of its basic principles, it is not possible to make constructivist art, this art that many believe to be infantile, because it looks so easy to practice, and also, since it is about belief, it requires more than passive or intellectual involvement.

There is no doubt that it is a doctrine. The dictionary says: 'Doctrine: Latin, doctrina, from docere, to teach. A body of beliefs advocated by a school, or dogmas professed by a religion.' There is all of this in Constructivist Art.

The sense of this doctrine is twofold; metaphysical and artistic, and it can be summarized as follows: art is defined as Harmony, and no other definition is acceptable. It is placed in a geometric plane, rejecting any manifestation that doesn't emanate from pure harmony. Therefore this art is founded in Rhythm, that is, proportion based on numbers. Its goal, no matter what form it takes, is to embody the law of Unity. Also, by being faithful to this principle, the constructivist artist becomes part of a Tradition that has given sustenance throughout the centuries. To be a constructivist implies a moral responsibility.

This undertaking clearly is the return to a Rule. It is bound to provoke new problems in art. But these only concern those who wish to reach universality by way of Constructivist Art.

J. Torres-García
October 1938.

THE TRADITION OF ABSTRACT MAN
(CONSTRUCTIVIST DOCTRINE)

In Art, in any given period, there is a wavering between two extremes: some art is inspired by ideas, some originates from an impression of reality. In other words, there is geometric art, and there is imitative art.

The general belief is that art moves from schematization to imitation. This is a mistake. The first artistic utterance is always imitative.

Geometric art is true art. Decadence, which does not understand this, annuls the sense of this true art by a fiction that is not pertinent.

Geometric art is universal. The maturity of a culture is a Science which includes it. For this reason, it (art) cannot be considered as separate. Based on this principle, before Constructivist Art there is a doctrine. Constructivist Art is the aesthetic expression of this doctrine. This doctrine is based on the law of Unity. From this law a Rule is deducted.

Starting from this rule, an Order is constituted and within this order everything is inscribed.

In this doctrine knowledge is total. And this knowledge therefore cannot be increased or diminished. Either you have this knowledge or you do not.

This knowledge, in its purity, can only be grasped by reason reflecting on itself.

To apprehend this totality requires an initiation: knowledge. Inherent in this understanding is a progressive order, based on a notion of Unity. From unity order proceeds and to unity it returns, and it creates ever new unities, to infinity.

From this knowledge of being, man takes his image, and at the same time, the (universal) image of man. Animals are similar but have no knowledge. So the difference between man and animal is knowledge through reason.

Reason is the key to knowledge.

Reason leads us to the knowledge of MAN. Everything is within man. Not on a small scale but in its true dimensions.

The tradition of civilization is the tradition of ABSTRACT MAN. The barbarian only exists in physical, concrete man.

The tradition of ABSTRACT MAN: tradition of construction. In all ages since prehistoric times, including that of the primitives, the Incas, the Aztecs, the Egyptians, the Greeks, the Middle Ages, it has been present. Inherent in the civilizations of all ages: from the caves to Architecture, from superstition to Philosophy, from force to Justice. It is a Tradition of knowledge incarnate in stone, hidden in symbol, as true yesterday as tomorrow, like the Sun.

De tal conocimiento, que es ser y estar, el hombre toma su figura, pero a su vez eso es la figura del hombre. El animal existe por eso, y como eso, pero no conoce. Y la diferencia entre el hombre y el animal, es que el hombre sabe por la razón.

La razón es la llave del conocimiento.

Nos lleva a conocer al HOMBRE. Todo está en él, no en pequeño, sino en su dimensión real. Aquí no hay dimensión.

La tradición de la civilización es la tradición del HOMBRE ABSTRACTO. El bárbaro solo vive en el hombre concreto, real.

Tradición del HOMBRE ABSTRACTO: tradición de construcción. El hombre de todos los tiempos: junto al prehistórico;

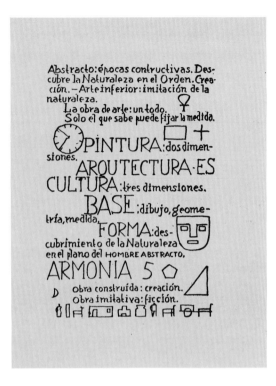

ABSTRACT MAN: equilibrium, order.

A letter, a sign carved on stone is the imprint of Abstract Man.

Average man (despite appearances) still lives in a barbaric state; he leads the life of the instincts.

ART: based on Abstract Man. Constructivist periods. Nature in Order. Creation. Inferior Art: imitation of nature.

The work of art: a whole.

Only he who knows can establish a measure.

PAINTING: two dimensions.

ARCHITECTURE IS CULTURE: three dimensions.

FOUNDATIONS: drawing, geometry, measure.

FORM: discovery of Nature at the level of ABSTRACT MAN. HARMONY.

Constructed work: creation.

Imitative work: fiction.

INDIVIDUALISM: outside the concept of MAN. A self-centred individual (outside the totality) is like a part without a harmonic relationship to the whole.

MATERIALISM: fragmented (partial, relative, accidental knowledge). EGOCENTRISM: existence outside the universal. The dominant human state. Main activity: finances. (Everything else is subordinate.) Activities of the self-centred man: utilitarian, practical, tangible, empirical, progressive and specialized. Basis: money.

ABSTRACT MAN: the key. We must reinstate him.

A temple, a poem, a painting manifest the universality of ABSTRACT MAN.

In another time which came later a new spirit opposed the INDIVIDUAL against the UNIVERSAL MAN. (That is until today.) NOW (today) at the edge of the struggle: the affirmation of Truth. Constructive work (keep the seeds in a secure place).

Abstain. Winter. Sleep.

NATURALISTIC ART. XX CENTURY. Outside the TRADITION OF MAN. Art with no foundation, fragmentary and circumstantial. Based on individualism.

To discover the inexhaustible through reason and the soul is today and always an affirmation of freedom. Rhythm: certain elements in a landscape, in the human figure, in a group of objects. Now we move to another level.

By turning our backs on Nature, we will resolve the problems on the canvas. Then, painting, architecture, sculpture and music will all be on the same level. There will be no more illusions of depth in a painting, no more objects against a background. The figure/ground duality disappears. The work will have Unity. Painting, sculpture, ceramics, murals will be sustained and based in that in which everything is based: in UNITY.

LONG AGO there was a tradition of knowledge, life lived within a totality. And they guarded the knowledge. This was not for amusement. It was to maintain a faith, a belief, a certainty in a lasting way. It was to give testimony. A religious act of human solidarity. Man discovered the abstract. When this was forgotten art became profane amusement. One day, here on earth, mankind rediscovered signs of ABSTRACT MAN, and didn't know how to interpret them, believing that they were merely decorative. Since then the notion of beauty dominated art. Its true sense lost, art became in turn: amusement, a noble pastime, the imitation of reality, and sensuality. Thus, the progression: genius, demiurge, and its peak: decadence. Naturalism, imitation, light (not chiaroscuro) enters painting (until today).

Constructivist Art seeks to find the forms of nature through geometry: life lives silently in a world without voids. The music of forms: love that is a plant; the sun that becomes a cross . . . or a hand. ALL IS ONE AND DIVERSE.

We counter the normal vision of things, the distorted vision of the eyes, with the internal vision. To truths we propose Truth, to the random segment, the grand curve; to what is relative, the law which is constant.

TODAY, XX Century: organization based on error. Different modes of activity: art, science, sociology, customs, all have to do with a single concept: total materialism.

Painting: the same basis: grounded in what is relative (the accidental).

Vision of the painter today: a white object that accidentally looks green or blue . . . In the abstract: there is one eternal white, a red, a blue which are invariable.

The public today refuses anything that is removed from reality (physical vision). And the artist is required to offer something that does not conflict with this materialistic view of life.

PLASTIC ART: a Harmony.

RHYTHM, HARMONY, FORM, PLASTIC QUALITIES, VALUES. Forms for their intrinsic value, not because they represent anything. Green, red, blue representing themselves. Before being an object, they are colour and tone as plastic values. The object is a means; tone and colour an end. In painting, what is concrete is plastic, and not what is represented; that is apparent reality.

Decorative Art: false art, graphic elements in ornamental combinations, arabesques (arbitrarily) applied to furniture, objects, architecture, ceramics or textiles and not determined by the STRUCTURE of the building, the furniture, the ceramic etc. Decorative art does not originate in geometry; it forces nature into it. Because of this it has nothing to do with geometric art. Decorative art is the art of the mediocre.

Colour is best when painted:
> on a boat
> on a machine
> on a traffic sign
> on an airplane

Plastic values are structured according to their functions.

There are horrible monuments in public squares all over the world (decorative monuments), conglomerations without an internal function that determines the different parts. Therefore: without plastic unity. (At the most they might have literary cohesion.) Official art. . . .

Those horrendous buildings in streets all over the world (decorative architecture) are also a conglomeration of parts: pediments, mouldings, cornices, garlands and caryatids, without any of these being determined by true constructive elements or corresponding to a function which would create harmony.

And those horrible pieces of furniture whose structure disappears under decorative embellishments, and the same with those 'artistic' vases, books, paintings and all kind of objects.

ART is a Tradition.

PAINTING is not Art, it is only a branch of it, and outside Tradition. It only exists from Venice to today.

That which can be called Painting, naturalistic art, but not imitative art, is also a creation, because it achieves a synthesis: a balance between the emotion of the painter and light and colour. The subject is only a pretext.

The life of a work will never be in the representation (that is another life, the everyday) but in the harmonies of plastic values. The purpose of a work resides in the life of its plastic elements.

A red may represent a tomato but (for the painter) it will first be a red. And it will be tone, light, form and emotion before being a tomato. If the viewer sees only a tomato, he will be missing the essence of painting. (Here I must point out the inconveniences of naturalistic Painting, which diverts the attention of the viewer to something secondary to painting: representation.)

The bad painter and the public value these things: the literary, the descriptive, the sentimental, the dramatic, the poetic, the expressive, the folkloric, all things foreign to Painting. They also value certain negative aspects of painting: bold brushstrokes (that they believe to be the marks of genius), exaggerated colours (fake intensity), nervous, dynamic lines (the pretention of elegance), thickness of paint (weakness parading as strength). Result: insolence, grossness, vulgarity.

Painting (indeed Art, which includes painting in its wide sweep) is rooted in how it is done; in the plastic elements, the

tone, the colour, the light; the visual synthesis balanced with the emotion of the painter.

Understanding this, the six great masters of the second Renaissance can be appreciated (the proper masters of painting, as opposed to Art); these are: Tintoretto, Veronese, Titian, El Greco, Velazquez, Goya.

Today this is how painting should be understood (painting, 'painting', just painting, not bound to anything else, but painters' painting). Imitative painting has nothing to do with this.

For the good painter light is inseparable from tone (light is not chiaroscuro, nor is tone colour) and tone from colour and colour from form: all fusing in rapid synthesis: a creation. And the true light of a picture will not be the imitation of real light, but another very different light that comes from a deep understanding of tone and how it can be harmonized; therein is the life of the work.

Velazquez was to achieve this fully; Impressionism took it to the extreme limit. Now we are at the end of a great period, and in real decadence. The XIX Century.

The XX Century (today) is something else. Today we are moving toward a new objective; from a state of search to a natural condition of order. From a state of revolution (Cubism) to establishing the real foundations which will allow free creation backed by a firm rule.

At the moment of its inception (a time already past) maybe it was based on intemperence, a desire for more freedom of expression, irresponsibility, daring and shamelessness, in a mocking and cruel vein, that brought about the change. A concept to which others after painful search and thought had barely dared to give utterance.

Why did Cézanne introduce constructivist lines in his impressionist works? Timidly, he was starting to see.

The revolution began. Cubism brought it to maturity. (At that time in Paris, as is always the case in that city, something new had to be said, and because to exaggerate Cézanne and to make a pastiche using African Art was amusing, they did it, and it worked, and, almost without wanting to they achieved more than they thought: the sorcerer's apprentice unchained hidden forces.)

It was believed that Cézanne and his followers were repairing the mistakes of the Impressionists, that they were concentrating on form again (neglected by the Impressionists) that with the purpose of becoming more rigorous, they decomposed it, 'cubed' it, geometrized it, in order to regain awareness of it, to penetrate it better.

No doubt that was their purpose (even Cézanne said so) but the result was something else (because of the right timing), and people became aware of it.

The bridge was built: believing that they were building a construction within a physical order, they actually created a construction within a metaphysical order: true structure.

The core of Modern Art.

This revolutionary period lasted twenty years extending in several directions that originated from Cubism: futurism, dada, neo-plasticism, surrealism.

From being hermetic, it became almost popular: advertising, industrial design, architecture, decoration, theatre.

It invaded other forms of art: music, literature, dance, poetry, cinema.

As a revolutionary period, this one, although very fertile, lasted too long. They ran out of themes, in trying to take their experiments to every area of sensibility.

Attempts were made to re-energize it. Tentatively, new experiments were tried that didn't bring results. They became a return to the past while modernizing it.

And revolutionary art? – art for the masses – art for the people? This is the mistaken view: art is not something that serves something else. It is neither imitation nor description. The art of the people is the art of the Universal Man.

WHAT DO WE SEE FOR THE FUTURE? Nothing new must be added. Correct the error. Return to the Universal, re-establish the classical notion of Unity. Return to the cosmic instead of the historical. We have the true rule for everything: compass, scales, measure. Always in HARMONY.

EVERYTHING IS WITHIN THE ABSTRACT MAN. One must not want to achieve anything that is outside or above him. Not try to be either beast or god: only man, in accord with total harmony. Balance.

MENTAL PLANE

EMOTIONAL PLANE MAN

PHYSICAL PLANE

Within all three we receive and we must return. We must be within the LAW.

HUMANITY IS A UNITY.

THE COSMOS IS A UNITY. WE MUST BE IN COMMUNION WITH THE WHOLE.

UNITY: THAT WHICH IS FUNDAMENTAL.

He who does not return love with love, work with work IS AN OUTLAW. If we receive we must give back, on every level.

BALANCE NEEDS TO BE ATTAINED: THE TOTAL MAN. (If he is in the universal he cannot dwell in anything conventional.) If he is in harmony with a UNIQUE SCIENCE he will be reflected in all human crafts and arts: in each he receives and to each he gives back because he is within the law. Man without a title or a label.

IF ONE LIVES WITHIN THE ORDER, LIFE AND ART ARE THE SAME. TO WORK AND WRITE POEMS, TO PAINT OR SWEEP OR COOK OR LECTURE.

ONLY THE PROFESSIONALS ARE OUTSIDE THE

ORDER. And there are professionals for all sorts of things. And they are almost not men.

Man has only to want to be a man. He must not try to transcend the cosmic sphere. Only to be a man within the law. And have a home, a wife and children to care for. Preservation of the human species. The house and the Sun. Night and day. A child, a fish, a flower: everything within order. And with all this Art.

THERE ARE HIERARCHIES, but only those imposed by the natural law are valid: father and son, the learned who know, a beautiful voice or grace in doing or speaking, etc. And he who has one thing may not have another. Only the totality counts.

All is matter and all is spirit. The greatest miracle is that of the real. Whatever contradicts the law is monstrous. Man must not desire or admire this.

What is always positive is the affirmation of the universal law. Intuition and order: construction. A fusion of life and Geometry: spirit and form; idea and object.

In man, cosmic measure. Measure for his works. The house, the temple in this measure. Furniture and objects; and his aspirations. And everything also within the law of numbers.

Reason is the real book of wisdom. To think is to form oneself.

REASON

 LIFE

REASON: the key. Without this key nothing can be 'known'. The laws that govern the Universe are the same as the laws of reason. Reason is eternal. Through it everything is present, actual. We must live in the eternity of reason – in thought – and in whatever corresponds to it, outside of ourselves, in Nature: in what never changes – in Order.

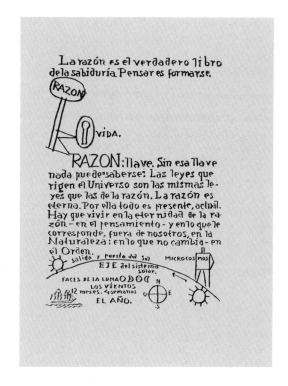

 sunrise and sunset MICROCOSMOS
 AXIS of the solar system.
 PHASES OF THE MOON
 THE WINDS
 12 months. 4 weeks
 A YEAR

Everything within the universal scope of Reason. (Tradition of Abstract Man.) Within this order: a time to rise and to lie down; to go out or to stay at home.

To adapt our life to Order.

Reason, passive in itself (an instrument) is without a doubt the faculty that allows man to uncover secrets, but also it allows him to construct. Induction – deduction.

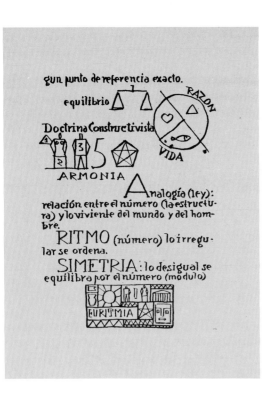

Geometry. The faithful contrast that allows an adjustment of what is perceived through the senses. Distanced from reason man doesn't have an exact point of reference.

balance REASON

Constructivist Doctrine

HARMONY LIFE

Analogy: (law); relation between numbers (structure) and the living world and man.

RHYTHM (numbers) orders that which is irregular.

SYMMETRY: what is not equal is balanced by numbers (according to a module).

The way to live and make art constructively is away from sensuality.

ARCHITECTURE: A sense of human balance, the ordering of man's place within Tradition.

ARTIST: the geometrist of the Universe: Universality.

WITHIN THE SAME LAW everything is numbers and everything is moral. 'Measure' is in everything and determines everything in constructivist art. ALL IS ONE.

Living Harmony is in man and in the architecture of objects, RHYTHM, deep in nature and in man: the law of life. Everything in life is based on numbers. Only the ignorant and the insensitive can refute this.

An object (a thing or a live being) in the geometrical order is an idea, something spiritual. A frontal plane allows the application of measure (i.e. pictorial Rhythm). It is therefore the true realization of symmetry.

Through complex associations of many orders of things, the ultimate goal of the constructivist man is to achieve that symmetry, that is UNITY. Through this a people will be called 'a culture'; that is, a human group which by relating the abstract to the real, finds its own unity of life within universal laws. Reason and Nature. Intuition and life on one side, Order and Universality on the other.

Man should not want to be above humanity. But he should not either want to be beneath it. To do this would be to be content to live on a materialistic level.

Man is man because of Reason. Through it he discovers the total order of things. Understanding, nothing is then material.

THE LIVING AND THE ABSTRACT ARE IDENTIFIED. AWARENESS OF THIS RELATIONSHIP PRODUCES KNOWLEDGE OF PROFOUND REALITY: LIFE AND GEOMETRY.
MAN UNIVERSE

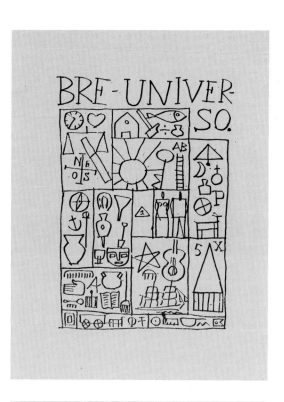

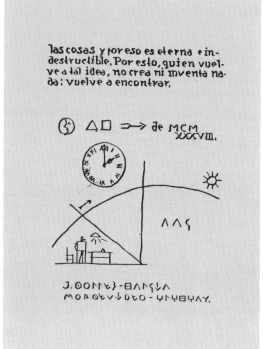

At this point of convergence stands the symbol. It is therefore neither illustration nor allegory: it is a sign. Tradition of the Abstract Man.

All primitive cultures exist along this line: because of this, their art is always a geometric expression, a ritual, something sacred.

This is the problem modern artists should consider today. Indeed the desire for this primitive expression has already been manifested in modern art.

Taking the term 'structure' onto the universal plane, we can define the nature of the sign, and then recognize that it (the sign) is where the life affirming and the abstract converge. This would be the best explanation for what we consider Constructive Art.

This is the idea to be pursued by men of any period. This is the basis of things and it is therefore eternal and indestructible. For this reason, he who returns to this principle does not create or invent: he rediscovers.

J. Torres-García
Montevideo, Uruguay, 1938

Translated by Cecilia Buzio de Torres

Chronology

This brief chronology is primarily devoted to personal events in Torres-García's life. The information has been compiled from the Torres-García archive in Montevideo. The chronology does not include exhibitions or publications; for documentation in these areas, the reader is referred to the selected exhibition history and bibliography on pages 125–7.

1874 28 July: Joaquín Torres-García is born in Montevideo, Uruguay, of a Catalan father and Uruguayan mother.

1891 The Torres-García family leaves for Catalonia, Spain, settling first in Mataró (home of Torres-García's father's family), then in Barcelona in 1892.

1893 Studies at Academia de Belles Arts and Academia Baixas.
Joins Cercle Artístic de Sant Lluc, a conservative artistic group.
Meets Joan and Julio González.

1904–05 Works on stained glass windows with Antoni Gaudí for the Cathedral in Palma de Mallorca, and for the Sagrada Família in Barcelona.

Torres-García (on right) with his mother, father and younger sister, Inés, Barcelona, 1892.

Torres-García, Barcelona, 1912.

Torres-García on the construction site of Antoni Gaudí's Sagrada Família, Barcelona, c.1905.

1907 Visits exhibition of French art at the *V Exposició Internacional de Belles Arts i Industries* in Barcelona. Is impressed by three cartoons by Puvis de Chavannes for the Paris Pantheon murals. Discovers Italian Primitives and Hellenistic art. Teaches at 'Mont d'Or', a progressive children's school.

1908 Paints frescoes in the chapel of the Holy Sacrament, Church of San Agustí, Barcelona with Joan González, and in the Church of the Divine Shepherdess in Sarrià. Paints frescoes for the Council Chamber, Barcelona. All of these frescoes will be painted over or destroyed.

1909 20 August: marries Manolita Piña de Rubiés.

1910 Travels to Paris, where he sees the Puvis de Chavannes murals at the Pantheon, and Brussels, where he decorates the ceiling of the Uruguayan Pavilion at the World's Fair.

1911 Daughter Olimpia is born.

1912 Travels to Florence and Rome to study fresco painting.
 Spends the summer in Switzerland, near Geneva. Son Augusto is born.

1912–13 Commissioned by Enric Prat de la Riba, leader of the Barcelona Provincial Government, to decorate the Saló de Sant Jordi in Barcelona's Palace of the Generalitat. The fresco commission will be interrupted, and work in progress covered over.

Torres-García, Manolita and their first child, Olimpia, Barcelona, 1912.

Torres-García with his new wife, Manolita Piña de Rubiés, Barcelona, c.1909.

1913 Writes and publishes his first book of artistic theory, *Notes sobre art*. In it, he encourages a return to a Graeco-Latin tradition.

1914 Leaves Barcelona to settle in Tarrasa (until 1919) at Villa 'Mon Repos'.
Makes his first wooden toys for children.

1915 Daughter Ifigenia is born.

1920 May: leaves Spain for New York, via Paris and Brussels. In Paris, while awaiting the crossing, stays at Hôtel de Rouen, a hotel run by Catalans where many Catalans stay. He is taken there by Joan Miró whom he had known in Barcelona. Meets many members of the Spanish/Catalan artistic community, as well as Jean and Sophie Taeuber-Arp.
July: sails for New York.

1920–22 In New York, receives moral and financial support from Isabelle Whitney. Tries unsuccessfully to get commissions for theatre and interior decorations, and for stained glass windows with Louis Comfort Tiffany; also tries to market children's toys. Is friendly with John Graham, Jean Xceron and Walter Pach.

1922 1 August: after an inconclusive stay in New York, returns to Europe. Settles in Italy, first in Genoa, then in Fiesole.

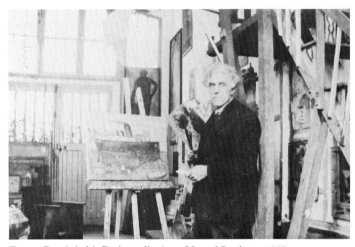

Torres-García in his Paris studio, 3 rue Marcel Sembat, c.1927.

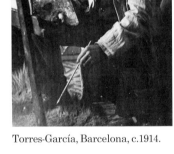

Torres-García, Barcelona, c.1914. Torres-García, New York, 1921.

Torres-García and Manolita in the studio, Paris, 1927; chair in foreground by Torres-García.

1924 20 April: moves to Livorno.
20 December: moves to Villefranche-sur-Mer in Southern France.
Son Horacio is born.

1926 19 September: settles in Paris. Jean Hélion lends him a studio for first two months at 1 rue Marcel Sembat. He then takes a studio on the ground floor at 3 rue Marcel Sembat.
Through Julio González meets Edgar Varèse and Luis Fernández.

1928 Meets Theo van Doesburg.
May–June: visits exhibition of pre-Columbian art, *Les Arts anciens de l'Amérique*, at the Musée des Arts Décoratifs.

1929 Meets Piet Mondrian, Georges Braque, Juan Gris, Jacques Lipchitz, Picasso, Le Corbusier, Cesar Domela, Michel Seuphor. Interested in Purism. Sends his children to study with Amédée Ozenfant. Son Augusto works with Julio González on metal sculptures for Picasso, and also at the Musée du Trocadéro, making renderings of Nazca pottery for inventory files.
Paints his first constructivist works.

1930 Founds *Cercle et Carré* with Michel Seuphor; it is dissolved within the year.
Spends the Summer in Losone, near Locarno, Switzerland.

1931 The effects of the New York Stock Market crash hit Paris.

Cercle et Carré exhibition, Galerie 23, Paris, 18 April 1930; from left to right: Michel Seuphor, unidentified woman, Georges Vantongerloo, unidentified man, Marcelle Cahn, Francisca Clausen, Florence Henri, unidentified man, Sophie Taeuber-Arp, Ingeborg H. Bjarnason, Jean Arp, Piet Mondrian, Nadia Léger, Luigi Russolo, unidentified woman, Torres-García, Friedrich Vordemberge-Gildewart, unidentified man, Jean Gorin, Manolita de Torres-García, Germán Cueto.

1932 15 December: moves family to Madrid; they live at Calle Maria de Molina 4 for eighteen months. Tries without success to form a school and museum of Constructive art.

A. E. Gallatin buys his first Torres-García works for the Museum of Living Art, New York.

1934 April: moves his family back to Montevideo. Writes his autobiography, *Historia de mi vida*. Between 1934 and 1937, does little painting. Devotes his energies to lecturing and writing theoretical texts.

1935 Creates *Asociación de Arte Constructivo* (Association of Constructivist Art). It becomes an intellectual centre in Montevideo and an important art school.

1936 May: begins publication of *Círculo y Cuadrado* (ten issues, until December 1934), a magazine inspired by the earlier *Cercle et Carré* in Paris.

1938 Builds *Cosmic monument* (see fig. 12) in Parque Rodó, Montevideo, a granite construction with carved symbols closely related to his paintings.

1939 Paints series of *Portraits* of famous men; the proportions in the paintings are based on the Golden Section.

1944 Forms *Taller Torres-García* (Torres-García Workshop), a working studio for teaching, and for collective commissions and work. The *Taller* executes an important set of murals for the Hospital of Saint Bois. (In 1974, to restore and

Arrival of the Torres-García family in Montevideo, 30 April 1934; from left to right: unidentified woman, Augusto, Ifigenia, Yepes (Olimpia's future husband), Olimpia, Horacio and cat, Manolita, Torres-García.

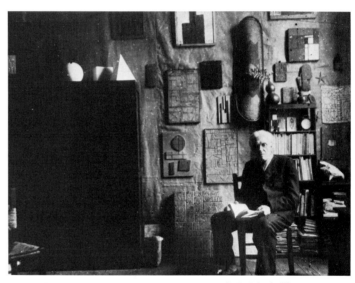

Torres-García in his first studio in Montevideo, Calle Isla de Flores 1715, c.1934.

First residence of the Torres-García family in Montevideo, Calle Isla de Flores 1715.

Torres-García, Montevideo, 1939.

conserve them, the murals were removed from the walls and mounted on panels. In 1978, while on exhibition in Rio de Janeiro, they were destroyed in a fire at the Museu de Arte Moderna.)

1945 January: begins publication of *Removedor* (twenty-six issues, until August 1953), a periodical issued by the *Taller*.

1949 8 August: Torres-García dies in Montevideo.

Torres-García in his studio, Montevideo, c.1939.

Torres-García in the garden of his home at Calle Abayuba 2781, Montevideo, 1948.

Torres-García (seated centre) with (from left to right): Damian Díaz Yepes, Manolita, Augusto, Ifigenia, Eva Díaz Yepes, Olimpia, Horacio, Montevideo, 1948.

Catalogue

The catalogue is arranged in approximate chronological order. Titles were not generally given by the artist; those cited here have been assigned by his family for purposes of identification.

Dimensions are given in centimetres (followed in parentheses by inches); height precedes width, followed, in the case of sculpture, by depth. For works on paper, sheet sizes are given.

Works on paper are exhibited either in the European or the American tour of the exhibition; an asterisk denotes the American tour.

The page number of the reproduction is given at the end of each entry. Numbers in parentheses which precede these refer to the inventory number of the work in the owner's collection.

1
Forms on white ground
1924
Oil on wood
31 × 14 cm (12¼ × 5½ ins)
Private Collection, New York
p.21

2
Abstract form
1926
Ink on paper
9.8 × 11.4 cm (3⅞ × 4½ ins)
Collection Royal S. Marks, New York
(795 AAJ)
p.22

3
Structure
1927
Ink on paper
8.5 × 10.5 cm (3⅜ × 4⅛ ins)
Collection Royal S. Marks, New York
(795 H)
p.22

4
***Tubular (pipe) construction**
1928
Ink on paper
10.6 × 8 cm (4⅛ × 3⅛ ins)
Collection Royal S. Marks, New York
(H 14)
p.22

5
***Drawing for a monument**
1928
Ink on paper
10.7 × 10.3 cm (4½ × 4 ins)
Collection Royal S. Marks, New York
(795 AAO)
p.22

6
Abstraction
1929
Ink on paper
19 × 13.5 cm (7⅝ × 5¼ ins)
Collection Torres-García Estate, New York
(445)
p.23

7
***Two abstract figures**
1929
Ink on blue paper
10.9 × 9.2 cm (4¼ × 3⅝ ins)
Collection Royal S. Marks, New York
(H 7)
p.23

8
Abstract form
1929
Ink on paper
13.5 × 9 cm (5⅜ × 3⅛ ins)
Collection Herbert F. Gower Jr and Royal S. Marks, New York (795 O)
p.23

9
Vertical and superimposed rhythms
1927
Oil on wood
18 × 20 cm (7⅛ × 7⅞ ins)
Private Collection, New York
p.25

10
Untitled
1929
Oil on wood
25 × 10.6 × 8.5 cm with base (9⅞ × 4⅛ × 3⅜ ins)
Private Collection, New York
p.24

11
Abstract mother and child
1929
Oil on wood
14 × 7 cm (5½ × 2¾ ins)
Private Collection, New York
p.24

12
Abstract form
1929
Oil on wood
25.5 × 3.4 × 3.5 cm (10 × 1⅜ × 1⅜ ins); base: 9.1 × 4.7 cm (3⅝ × 1⅞ ins)
Private Collection, New York
p.26

13
Counterpoint
1929
Oil on wood
20 × 5 cm (7⅞ × 2 ins)
Private Collection, New York
p.26

14
Construction
1928
Ink and pencil on paper
17.5 × 11.5 cm (6¾ × 4½ ins)
Collection Torres-García Estate, New York
(285)
p.27

79
***Abstract tubular**
1935
Pencil on paper
21.9 × 13.9 cm (8⅝ × 5½ ins)
Collection Royal S. Marks, New York
(H 46)
p.70

80
Drawing
not dated (post-1935)
Pencil on yellow paper
17 × 7.5 cm (6¾ × 3 ins)
Collection Torres-García Estate, New York
(899)
p.70

81
Drawing
not dated (post-1935)
Pencil on yellow paper
17 × 7.5 cm (6¾ × 3 ins)
Collection Torres-García Estate, New York
(895)
p.70

82
Abstract structure with integrated geometric forms
1935
Oil on board
50 × 40 cm (19¾ × 15¾ ins)
Private Collection, New York
p.71

83
Structure
1935
Oil on board
49.3 × 40.6 cm (9⅜ × 16 ins)
Collection Museo de Bellas Artes, Caracas
p.72

84
***Abstract tubular**
1937
Ink and pencil on paper
16 × 12.5 cm (6¼ × 4⅞ ins)
Collection Royal S. Marks, New York
(795 AF)
p.73

85
***Study for rhythm with obliques in black and white**
1937
Ink and wash on paper
11.8 × 10.5 cm (4⅝ × 4⅛ ins)
Collection Herbert F. Gower Jr and Royal S. Marks, New York
(795 AAT)
p.73

86
Tubular composition
1938
Pencil on paper
16.5 × 8.5 cm (6½ × 3⅜ ins)
Collection Royal S. Marks, New York
(795 AAN)
p.73

87
Abstract tubular with figures
1938
Pencil on paper
19 × 12.5 cm (7½ × 4⅞ ins)
Collection Royal S. Marks, New York
(795 AG)
p.73

88
Abstract tubular composition
1937
Tempera on board
81 × 101 cm (31⅞ × 39¾ ins)
Collection Royal S. Marks, New York
(805)
p.74

89
Rhythm with obliques
1938
Tempera on board
81.5 × 48.5 cm (32⅛ × 19⅛ ins)
Collection Royal S. Marks, New York
(847)
p.75

90
Constructive painting 3
1937
Oil on board
68.7 × 48.3 cm (27 × 19 ins)
Collection Royal S. Marks, New York
(801)
p.76

91
Universal art
1937
Oil on canvas
97 × 117 cm (38¼ × 46 ins)
Private Collection, New York
p.77

92
Constructivist painting in white and black (INTI)
1938
Tempera and casein on cardboard
81 × 101.8 cm (31⅞ × 40 ins)
Collection Herbert F. Gower Jr and Royal S. Marks, New York
(807)
p.78

93
Untitled
1938
Gouache on cardboard on wood
81.3 × 43.1 cm (32 × 17 ins)
Collection Albright-Knox Art Gallery, Buffalo, New York; gift of The Seymour H. Knox Foundation, Inc., 1967
p.79

94
Artefacts in black and white
1938
Pencil on paper
13 × 10.5 cm (5⅛ × 4⅛ ins)
Collection Royal S. Marks, New York
(795 AY)
p.80

95
***Shaded forms**
1938
Pencil on paper
16.8 × 11 cm (6⅝ × 4⅜ ins)
Private Collection, New York
p.80

96
Composition
1938
Gouache on board mounted on masonite
81.3 × 101.6 cm (32 × 40 ins)
Collection The Solomon R. Guggenheim Museum, New York, Gift, Mr and Mrs Walter Nelson Pharr
p.82

97
***Two abstract figures**
1937
Pencil on paper
9 × 13.5 cm (3½ × 5⅜ ins)
Private Collection, New York
p.80

119
Constructive painting 12
1943
Oil on board
83.8 × 101.6 cm (33 × 40 ins)
Courtesy Sidney Janis Gallery, New York
p.98

120
Constructive painting 16
1943
Oil on board
40.7 × 62.2 cm (16 × 24½ ins)
Collection Royal S. Marks, New York
(802)
p.99

121
Drawings and symbols
not dated
Pencil on paper
Sheet one: 15 × 10 cm (5⅞ × 4 ins)
Sheet two: 22 × 14 cm (8⅝ × 5½ ins)
Sheet three: 20 × 15 cm (7⅞ × 5⅞ ins)
Collection Torres-García Estate, New York
(1071)
p.100

Publications
The following publications are included in
the exhibition as documentation.

J. Torres-García, *Metafísica de la
Prehistoria Indoamericana,* Montevideo,
Publicaciones de la Asociación de Arte
Constructivo, 1939

J. Torres-García, *La Ciudad sin nombre,*
Montevideo, Asociación de Arte
Constructivo, 1941

Círculo y Cuadrado, Montevideo, nos.8, 9,
10, December 1943

*Removedor: Revista del Taller Torres-
García,* no. 4, April-May 1945

*Removedor: Revista del Taller Torres-
García,* no. 7, September 1945

J. Torres-García, *Père soleil,* text dated Paris
le 29 juillet 1931; a facsimile of the original
edition, edited by the Fundación
Torres-García with the collaboration of the
Ministerio de Education y Cultura and
published to commemorate the first
centenary of the artist's birth, Montevideo,
June 1974

Selected exhibitions

The list of exhibitions has been compiled primarily from published sources. Early exhibitions in Barcelona are particularly difficult to document and further research in this area remains to be done. Exhibitions are listed in chronological order.

I. One-man exhibitions

The list of posthumous exhibitions includes only those exhibitions held in museums.

Barcelona, Saló de 'La Vanguardia', 1900

Barcelona, Cercle Artístic de Sant Lluc, joint exhibition with Ivo Pascual, opened 16 January 1904

Barcelona, Saló de 'La Publicidad', May 1907

Barcelona, Galeries del Faianç Català, opened 15 October 1911

Barcelona, Galeries del Faianç Català, 1912

Barcelona, Galeries Dalmau, *Exposició de Dibuixos y Pintures de J. Torres-García*, opened 19 January 1912; catalogue introduction by Eugeni d'Ors

Barcelona, Galeries Dalmau, May 1913

Tarrasa, Gremi d'Artistes, *Exposició d'estudis de J. Torres-García*, August 1913

Barcelona, Galeries Laietanes, 1916

Barcelona, Galeries Dalmau, joint exhibition with Rafael Barradas, 1916; catalogue

Barcelona, Galeries Dalmau, February 1917; catalogue

Barcelona, Sala Reig, October 1917; catalogue

Barcelona, Galeries Laietanes, 1917

Barcelona, Galeries 'La Publicidad', 1917

Barcelona, Galeries Dalmau, September 1918; catalogue introduction by J. Torres-García

Barcelona, Galeries Dalmau, opened 20 December 1918; exhibition of toys; catalogue introduction by J.Torres-García

Bilbao, Salón de la Asociación de Artistas Vascos, opened 5 March 1920

New York, Gallery Hanfstaengel, 1922

Barcelona, Galeries Dalmau, June 1926; catalogue

Paris, Galerie A. G. Fabre, *Exposition Torrès-Garcia*, 7–20 June 1926; catalogue introduction by Juan de Gary

Paris, Galerie Carmine, *J. Torrès-Garcia*, 16–30 June 1927; catalogue introduction by Joseph Milbauer

Paris, Galerie Zak, *Quelques peintures récentes et rétrospectives de Torrès-Garcia*, 1–7 December 1928; catalogue introduction by Waldemar George

Barcelona, Galeria A. Badrinas, 15–30 December 1928; catalogue

Barcelona, Galeries Dalmau, November 1929

Paris, Galerie Jeanne Bucher, *Peintures de Torrès-Garcia*, 30 January–14 February 1931; catalogue preface by Waldemar George

Paris, Galerie Percier, 30 November–12 December 1931

Paris, Galerie Jean Charpentier, opened 2 December 1931

Paris, Galerie Pierre, 4–18 March 1932

Madrid, Museo de Arte Moderno, March–April 1933

Madrid, Sociedad de Artistas Ibéricos, *Exposición J. Torres-García*, 8–29 April 1933

Barcelona, *L'obra pictòrica de Joaquím Torres-García exposada al Cercle Artístic de Sant Lluc*, 24 May–11 June 1933

Montevideo, Amigos del Arte, June 1934

Montevideo, Asociación Cristiana de Jóvenes, *Exposición de obras de Joaquín Torres-García*, opened 10 July 1934; catalogue introduction by Joaquín Torres-García

Montevideo, Escuela Taller de Artes Plásticas, 1934

Montevideo, Ateneo de Montevideo, 1935

Montevideo, Asociación Cristiana de Jóvenes, 1936

Montevideo, Sociedad de Arquitectos del Uruguay, opened 26 November 1940

Montevideo, Intendencia Municipal de Montevideo, *Exposición Joaquín Torres-García*, opened 31 July 1941; catalogue introduction by J. Torres-García and E. Yepes

Buenos Aires, Galería Müller, opened 22 September 1942

Montevideo, Amigos del Arte, opened 4 May 1944

Montevideo, Salón Caviglia, opened 24 October 1944

Montevideo, Librería Salamanca, *Exposición Torres-García,* June–July 1945; *Obras recientes*, opened 28 June; *Arte constructivo*, opened 19 July; *Obras retrospectivas* opened 20 July

Montevideo, Salón del Ateneo de Montevideo, April–May 1947

Montevideo, Amigos del Arte, opened 19 May 1948

Montevideo, Amigos del Arte, opened 28 July 1949

Barcelona, Galeries Laietanes, December 1949–January 1950

Buenos Aires, Instituto de Arte Moderno, *Joaquín Torres-García: pinturas*, April 1951; catalogue introduction by Guillermo de Torre and Alvaro Fernández Suárez

Montevideo, Salón de la Comisión Municipal de Cultura, opened 3 August 1951; catalogue by Francisco Espínola

Montevideo, Taller Torres-García, opened 8 August 1954

Montevideo, Museo Torres-García, July 1955; catalogue by Francisco Espínola

Paris, Musée National d'Art Moderne, *Joaquín Torres-García*, 22 November–December 1955; catalogue texts by Jean Cassou and José Bergamín

Venice, *XXVIII Biennale di Venezia*, Palazzo Centrale, Sala LIX Uruguay, Sala Torres-García, 1956

Montevideo, Salón de la Comisión Nacional de Bellas Artes, July 1957

Montevideo, Museo Torres-García, July 1957

São Paulo, *V Bienal*, 'Sala Torres-García: 37 obras comprendidas en el periodo 1929–1947', September–December 1959; catalogue text by Guillermo de Torre

Montevideo, Centro de Arte y Letras, opened 21 March 1960; catalogue text by Jean Cassou

Washington, D.C., Pan American Union, 19 April–5 May 1961; exhibition travelled by Smithsonian Institution to San Francisco, San Francisco Museum of Art, 13 July–15 August 1961; accompanied by catalogue from exhibition at Rose Fried Gallery, New York, *J. Torres-García: Paintings from 1939–1949*

Amsterdam, Stedelijk Museum, *Joaquín Torres-García,* December 1961–January 1962; travelled to Baden-Baden, Staatliche Kunsthalle, 2 March–1 April 1962; catalogue

Montevideo, Comisión Nacional de Bellas Artes, December 1962; catalogue text by Francisco Espínola with excerpts from writings by Torres-García

Buenos Aires, Centro de Artes Visuales de Instituto Torcuato di Tella, November 1964; catalogue text by Jorge Romero Brest

Montevideo, Amigos del Arte, opened 25 October 1965; catalogue texts by Juan José Fló and Waldemar George (written in Paris 1928)

Montevideo, Museo Torres-García, August 1969; catalogue text by Esther de Cáceres

Ottawa, The National Gallery of Canada, *Joaquín Torres-García 1874–1949*, October 1970; exhibition organized in collaboration with and travelled to New York, The Solomon R. Guggenheim Museum, December 1970–January 1971; Providence, Museum of Art, Rhode Island School of Design, February 1971; catalogue introduction by Daniel Robbins

Austin, The University of Texas at Austin, The University Art Museum, *Joaquín Torres-García*, 1 December 1971–16 January 1972; catalogue with texts by Monroe Wheeler and Donald B. Goodall; curated by Barbara Duncan

Madrid, Museo Español de Arte Contemporáneo, *Joaquín Torres-García: Exposición antológica*, April–May 1973; catalogue with texts by José Pedro Argul and Enric Jardí

Barcelona, Museu d'Art Modern, June–September 1973; travelled to Madrid, Museo Español de Arte Contemporáneo

Montevideo, Museo Nacional de Artes Plásticas, *Torres-García*, opened 28 July 1974; catalogue introduction by Angel Kalenberg; travelled to Buenos Aires, Museo Nacional de Artes Plásticas

Austin, The University of Texas at Austin Art Museum, Archer M. Huntington Galleries, *Joaquín Torres-García 1874–1949: Chronology and Catalogue of the Family Collection*, 13 October–24 November 1974; catalogue by Barbara Duncan and Donald B. Goodall

Caracas, Museo de Arte Contemporáneo, *Joaquín Torres-García*, January 1975

Paris, Musée d'Art Moderne de la Ville de Paris, *Torres-García 1874–1949: Construction et symboles*, 11 June–18 August 1975; catalogue with texts by Jacques Lassaigne and Angel Kalenberg with 'Témoignages' by Maria Eléna Vieira da Silva, Michel Seuphor, Jean Hélion and Pablo Serrano

Rio de Janeiro, Museu de Arte Moderna, *Joaquín Torres-García: Geometria Sensibel*, 8 June–22 July 1978 (the entire exhibition, 78 works including murals of 1944 which had been removed from the walls of the Hospital of Saint Bois, Montevideo, mounted on panels and donated to the Museo Nacional de Artes Plásticas, Montevideo by the Torres-García Foundation, was destroyed in a fire at the museum)

Paris, Musée d'Art Moderne de la Ville de Paris, *Hommage à Torres-García* (drawings), June–July 1979; catalogue with texts by Jacques Lassaigne, Jean Cassou and Santos Torroella

São Paulo, Museu de Arte de São Paulo, Assis Chateaubriand, *Joaquín Torres-García*, September–October 1979

Caracas, Museo de Bellas Artes, *Joaquín Torres-García: Su visión Constructiva*, May 1980; catalogue by Adolfo Maslach, also includes interview with Manolita de Torres-García

Mexico City, Museo de Arte Moderno, *Joaquín Torres-García, 1874–1949*, January–March 1981; catalogue by Ieda Brandao

Nuevo Leon (Mexico), Monterrey, Museo de Monterrey, *Joaquín Torres-García*, April–June 1981; catalogue by Ieda Brandao and Javier Martinez

London, Hayward Gallery, *Torres-García: Grid-Pattern-Sign (Paris–Montevideo 1924–1944)*, 14 November 1985–23 February 1986; exhibition organized by the Arts Council of Great Britain and travelled to Barcelona, Fundació Joan Miró, 13 March–4 May 1986; Düsseldorf, Städtische Kunsthalle Düsseldorf, July/August 1986; catalogue introduction by Margit Rowell

II. Group exhibitions

Posthumous exhibitions are not included.

Barcelona, *Sala Parés*, 1906

Barcelona, *Sala Parés*, 1908

Barcelona, *Saló de Les Arts i els Artistes*, 1913

Barcelona, *Primer Saló de Tardor*, December 1918

New York, Waldorf Astoria Hotel, *Fifth Annual Exhibition of Society of Independent Artists*, 26 February–24 March 1921

New York, The Whitney Studio Club, *J. Torres-García, Stuart Davis and Stanislaw Szukalski*, 25 April–15 May 1921

New York, The Whitney Studio Club *Annual Exhibition of Paintings and Sculpture*, April–May 1922

Paris, Salon d'Automne, 1 November–14 December 1924

Paris, Salon d'Automne, 26 September–2 November 1925

Barcelona, Galeries Dalmau, *Exposició i venda de quadres antics i moderns*, May 1925

Barcelona, Galeries Dalmau, *Exposició del Modernisme pictóric català confrontada amb una selecció d'obras d'artistes d'avant-guarda estrangers*, October–November 1926

Paris, Galerie d'Art de Montparnasse, 16–28 May 1927

Paris, Salon des Indépendants, 20 January–29 February 1928

Paris, Galerie Marck, *Cinq Peintres refusés par le Jury du Salon d'Automne*, 13–30 November 1928

Barcelona, Galeries Dalmau, *Exposició col·lectiva neo-plàstica*, 1929

Paris, Editions Bonaparte, *Exposition d'Art abstrait*, 13 July–2 August 1929

Paris, Porte de Versailles, *Les Surindépendants*, 26 October–25 November 1929

Barcelona, Galeries Dalmau, *Exposició d'Art Modern Nacional i Estranger, Secció Local,*, 31 October–15 November 1929; preface by M. A. Cassanyes

Bordeaux, *Société des Artistes Indépendants*, October 1929

Paris, Galerie Zak, *Première Exposition du Groupe Latino-Américain*, 11–24 April 1930; catalogue introduction by H. D. Barbagelata

Paris, Galerie 23, *Première Exposition internationale du Groupe Cercle et Carré*, 18 April–1 May 1930

Paris, Porte de Versailles, *Deuxième Salon des Surindépendants*, June 1930

Paris, *Salon des Indépendants*, November 1930

Paris, Salle d'Art Castelucho Diana, *Huit Artistes du Rio de la Plata*, 2–14 December 1930

Lodz, Musée de Lodz, 1931; exhibition organized by Henri Stazewski

Paris, Galerie Billiet, *Casa de Catalunya*, 26 June–9 July 1931

Paris, Galeries Georges Petit, 14–31 October 1931

Paris, Porte de Versailles, *Troisième Salon des Surindépendants*, 23 October–22 November 1931

Barcelona, Sala Badrinas, *Exposició col·lectiva*, 19 December 1931–9 January 1932

Paris, Studio de la Librairie de l'Opéra, *Groupe d'artistes*, 26 February–12 March 1932

Paris, Galerie Zak, *Troisième Exposition du Groupe Latino-Américain*, 27 June–10 July 1932

Paris, Porte de Versailles, *Quatrième Salon des Surindépendants*, November 1932

Madrid, Escuela de Bellas Artes, *Exposición de Artes*, August 1933

Madrid, Salón de Otoño, *Primero Exposición del Grupo de Arte Constructivo*, October 1933

Paris, Porte de Versailles, *Cinquième Salon des Surindépendants*, October–November 1933

New York, Museum of Living Art, 1933

Montevideo, Estudio 1037, *Exposición de Pintura y Escultura*, August 1934

Montevideo, Club Español, December 1935

Paris, Porte de Versailles, *Huitième Salon des Surindépendants*, October 1936

Paris, Porte de Versailles, *Neuvième Salon des Surindépendants*, January 1937

Montevideo, Ateneo de Montevideo, *Primero Salón de los Independientes de Artes Plásticas*, August 1937

Montevideo, Asociación de Arte Constructivo, *Quinto Exposición*, March 1938

Montevideo, Amigos del Arte, *Exposición Taller*, October 1940

Montevideo, Ateneo de Montevideo, *Exposición de la Asociación de Arte Constructivo en Homenaje a la Signora Rosa Lanza*, October 1940; catalogue introduction by Joaquín Torres-García

Montevideo, *Segundo Salón Municipal de Artes Plásticas*, 3–30 October 1941

Montevideo, Ateneo de Montevideo, *Taller Torres-García*, May 1943

New York, The Museum of Modern Art, *The Latin American Collection of the Museum of Modern Art, New York*, October 1943; catalogue introduction by Lincoln Kirstein

Montevideo, Salón Municipal, *Ve Salón de Otoño*, 14 April–6 May 1944

Montevideo, *Octavo Salón Nacional de Bellas Artes*, August–September 1944

Montevideo, Amigos del Arte, *Heroes, Hombres y Monstruos*, October 1945

Montevideo, Arte Bello, *Exposición Paisaje Uruguayo*, January–February 1946

Montevideo, Salón Municipal, *VII Salón de Otoño*, May 1946

Paris, Maison de l'Amérique Latine, *Ars Americana*, 18 October–5 November 1946; catalogue introduction by René Huyghe

Punta del Este, Casino Miguez, *Exposición de Pintores Uruguayos*, January–February 1948

Selected bibliography

The following list includes only books written by the artist and monographs written on his work. For a fuller list of writings by and on Torres-García, the reader is referred to *Joaquín Torres-García 1874–1949* (catalogue of an exhibition, published by the Museum of Art, Rhode Island School of Design, Providence, 1970) and to *Joaquín Torres-García: Bibliografía,* Biblioteca Nacional, Montevideo, 1974.

I. Writings by the artist

Notes sobre art, Gerona, Rafael Masó, 1913; excerpt reprinted in *Revista de L'Escola de Decoració,* Barcelona, March 1914, pp.1–5, 10, 27; reprinted in *Escrits sobre art* (edited by F. Fontbona), Barcelona, Eds. 62 i 'La Caixa', 1980

Diàlegs, Tarrasa, Tipografia Mulleras, 1915

Un ensayo de clasicismo: La orientación conveniente al arte de los países del mediodía, Tarrasa, Tipografia Mulleras, 1916

El descubrimiento de sí mismo: Cartas a Julio que tratan de cosas muy importantes para los artistas, Gerona, Rafael Masó, 1917

L'art en relació amb l'home etern i l'home que passa, Sitges, Imp. El Eco de Sitges, 1919

La regeneració de sí mateix, Barcelona, Salvat-Papasseit, 1919

Ce que je sais, et ce que je fais par moi-même: Cours complet de dessin et de peinture, et d'autres choses (with drawings), text dated Losone 5 septembre 1930; Montevideo, Imprenta As, 1974

Manifiestos del Grupo Arte Constructivo, written Paris, 1930; broadsheets, nos.1,2,3, Montevideo, 1934

Père soleil (with drawings), text dated Paris le 29 juillet 1931; Montevideo, Imprenta As, 1974

Raison et nature: Théorie (with drawings), text dated Paris mai 1932; Montevideo, Imprenta As, 1974

Guiones, broadsheets, nos.1,2,3, Madrid, 1933

Historia de mi vida (with drawings), text dated Montevideo, octubre de 1934; Montevideo, Asociación de Arte Constructivo, 1939

Estructura, text dated julio de 1935; Montevideo, Ed. Alfar, 1935; republished Montevideo, Ediciones de la Regla de Oro, 1974

La Tradición del Hombre Abstracto (Doctrina constructivista) (with drawings), Montevideo, 1938; second edition published Montevideo, Imprenta As, 1974; prologue reprinted in *La Idea,* Paso de los Toros, 15 September 1951

Metafísica de la Prehistoria Indoamericana, Montevideo, Publicaciones de la Asociación de Arte Constructivo, 1939

500a conferencia de las dadas por J. Torres-García en Montevideo entre los años 1934 y 1940, text dated 12 de noviembre de 1940 (also includes texts of 20 and 28 November); Montevideo, Asociación de Arte Constructivo, 1940

Mi opinión sobre la exposición de Artistas Norteamericanos: Contribución al problema del arte en America, text dated 5 de setiembre de 1941; Montevideo, Asociación de Arte Constructivo, 1942

La Ciudad sin nombre (with drawings), Montevideo, Asociación de Arte Constructivo, 1941; reprinted in *Removedor,* vol.1, no.5, Montevideo, 1942

'Una decoración mural en la moderna estética realista', text dated julio de 1944; in *La decoración mural del Pabellón Martirené de la Colonia Saint Bois,* Montevideo, 1944

Universalismo Constructivo, Buenos Aires, Editorial Poseidón, 1944 (includes articles written and published during the 1930s and 1940s); extract reprinted in *La Idea,* Paso de los Toros, 24 October 1950; reprinted Madrid, Editorial Alianza, 1984 (2 vols.)

La regla abstracta (with drawings), text dated 5 de febrero de 1946; Buenos Aires, Ed. Ellena, 1967; printed as an article in *Nueva Escuela de Arte del Uruguay,* Montevideo, 1946; printed in part in *Espacio,* nos.9–10, Peru, December 1951, p.4

Mística de la pintura, text dated 5 de febrero de 1947; Montevideo, Asociación de Arte Constructivo y Taller Torres-García, 1947

Lo aparente y lo concreto en el arte, Montevideo, Asociación de Arte Constructivo y Taller Torres-García, 1947

La recuperación del objeto, 2 vols., Montevideo, Universidad de la República, 1952; reprinted 1965 with prologue by Esther de Cáceres, edited by Biblioteca Artigas

Escritos (edited by Juan José Fló), Montevideo, Arca Editorial, 1974 (selected excerpts)

II. Monographs

Argul, José Pedro, *Arte de las Américas, Joaquín Torres-García,* Montevideo, Editorial Mosca Hnos., not dated

Ràfols, Josep F., *Torres-García,* Barcelona, Monografies d'Art, Edicions Quatre Coses, 1926

Payró, Roberto J. and Torre, Guillermo de, *Torres-García,* Madrid, Imprenta Graphia, 1934

Cáceres, Alfredo, *Joaquín Torres-García,* Montevideo, 1941

Schaefer, Claude, *Joaquín Torres-García,* Buenos Aires, Editorial Poseidón, 1945

Podestà, José María, *Joaquín Torres-García,* Monografías de Arte, Buenos Aires, Editorial Losada, S.A., 1946

Cassou, Jean, *Torrès Garcia,* Paris, Fernand Hazan, 1955

Cáceres, Esther de, *Vida de un artista uruguayo, Joaquín Torres-García,* Montevideo, Consejo Nacional de Enseñanza Primaria y Normal, 1957

Fló, Juan J. and Ferre, Alberto Methel, 'Joaquín Torres-García', Montevideo, *Revista Artes,* no.2, August 1959 (entire issue)

Payró, Julio E., *Joaquín Torres-García,* Pinacoteca de los Genios, Buenos Aires, Editorial Codex, 1966

Jardí, Enric, *Torres-García,* Biblioteca de Arte Hispánico, Barcelona, Ediciones Polígrafa, S.A., 1973; English edition translated by Kenneth Lyons, 1974; French edition translated by Joëlle Guyot and Robert Marrast with preface by Jacques Lassaigne, Paris, Editions Cercle d'Art, 1979

Joaquín Torres-García: Bibliografía, Montevideo, Biblioteca Nacional, 1974

Castillo, Guido, *Primer Manifiesto del Constructivismo de Joaquín Torres-García,* Madrid, 1975

Gradowczyk, Mario H., *Joaquín Torres-García,* Buenos Aires, Ediciones de Arte Gaglianone, 1985; in Spanish and English editions

Photographic credits

The publishers wish to thank the owners of works reproduced in this catalogue for kindly granting permissions and for providing photographs.

The publishers have made every effort to contact all holders of copyright works. All copyright-holders we have been unable to reach are invited to contact the publishers so that a full acknowledgment may be given in subsequent editions.

Photographs have been supplied by owners and by those listed below:

Colour

D. James Dee, New York: nos. 9, 19, 24, 25, 36, 54, 62, 65, 71, 105
Eric Pollitzer, New York: nos.38, 59, 73, 90, 101, 116

Black and white

Sergio de Castro o Mandello: p.117 (Calle Abayuba)
Courtesy CDS Gallery, New York: nos.42, 47, 49
Chisholm, Rich & Associates, Photography, Houston: nos. 48, 74
Geoffrey Clements, New York, courtesy Sidney Janis Gallery:
nos.44, 104, 119
D. James Dee, New York: nos.1, 6, 10, 11, 12, 13, 15, 16, 18, 22, 23, 26, 27, 28, 29,
31, 35, 37, 39, 43, 46, 53, 55, 56, 61, 64, 66, 67, 68, 72, 80, 81, 82, 89, 91, 95, 97, 98,
102, 103, 106, 108, 110, 115, 117, 121; fig.4
Jacques Faujour, Paris: no.112
Bobby Hanson: nos.45,114
Museo Arqueológico Nacional, Madrid: figs.10, 11
Photothèque Musée de l'Homme, Paris: figs.3 (J. Oster), 5, 6 (D. Ponsard),
7, 8, 9
Santiago Piña de Rubiés: p.114 (Paris, 1927)
Eric Pollitzer, New York: nos.2, 3, 4, 5, 7, 8, 17, 30, 32, 34, 50, 51, 52, 60, 69, 70,
75, 76, 77, 78, 79, 84, 85, 86, 87, 88, 92, 94, 107, 109, 120
Margit Rowell: fig.12; p.116 (residence)
Courtesy Salander O'Reilly Galleries, Inc., New York: nos.41, 111
Service photographique du Musée National d'Art Moderne, Centre
National d'Art et de Culture Georges Pompidou, Paris: fig.2
Courtesy of Sotheby's Inc., New York: no.58
Alfredo Testoni, Montevideo: no.20; p.117 (family portrait)